EXETER

THROUGH TIME

Darren Marsh

AMBERLEY PUBLISHING

For Mum and Dad, Catrina and Russ, Francesca and Toby, and Annie...

First published 2013

Amberley Publishing
The Hill, Stroud, Gloucestershire, GL5 4EP
www.amberley-books.com

Copyright © Darren Marsh, 2013

The right of Darren Marsh to be identified as the
Author of this work has been asserted in accordance with
the Copyrights, Designs and Patents Act 1988.

ISBN 978 1 4456 1386 4 (print)
ISBN 978 1 4456 1394 9 (ebook)

British Library Cataloguing in Publication Data.
A catalogue record for this book is available from the
British Library.

Typesetting by Amberley Publishing.
Printed in Great Britain.

Introduction

When we build, let us think that we build forever.
John Ruskin, *The Seven Lamps of Architecture* (1849)

Building 'forever' is a lovely thought, but my researches for this book have highlighted that nothing, not even the cathedral, is immune from change. Remodelling, extending, demolishing and starting again, adapting to current fashions or reflecting fluctuating circumstances – all these have left their mark on Exeter's built heritage. I have been unable, in around eighty words per page, to bring you the full story of any of our wonderful buildings, and I would urge you to treat this book as a menu; once you've found something of interest, commit to a full exploration!

It's often the plain, the workaday or the otherwise obscure that is the most intriguing. Patterns emerge during research, themes have woven themselves into the fabric of our buildings, the same names reoccur – Kennaway, Baring, Hooker, Nosworthy, Grandisson – and so we begin the see the glue that holds everything together. We need stability, continuity, leadership and forbearance in order to face the challenges of the day.

To satisfy those who believe in the need for constant change and so-called progress, we have the new Science Park, the Met Office, another new Princesshay, and the ever-expanding airport. So why is it that we turn to yesterday for relaxation, inspiration, peace and security? Where would we be without the National Trust, *Antiques Roadshow*, *Time Team*, Dickens, Austen, Shakespeare, Wren and Chippendale? This is where we find the continuous thread of life. This is where we find the beauty that Ruskin exhorts us to create. This is where we find that which is most precious.

The interior of the cathedral, the Law Library roof, St Edmund's Bridge, the Custom House, Baring Crescent, all are important, all

are beautiful. All are, indeed, life-enhancing. Ruskin's ideal was a noble one; we have let him down if we don't see these things for what they are.

Many of Exeter's fine buildings are enhanced by their settings – parks, gardens, the river, or a backdrop of rolling hills. Often these buildings are, in origin, older than they appear, and they somehow seem to be just the right size. A charming mixture of heights and widths, of higgledy-piggledy fenestration, of sagging and soaring rooflines, together with cobbles, flagstones, Gothic lamp posts, murals, sculpture, bridges, and great wooden doors. We are fortunate to spend time here. Enjoy it. And thank you for reading my book.

<div align="right">Darren Marsh, Exeter</div>

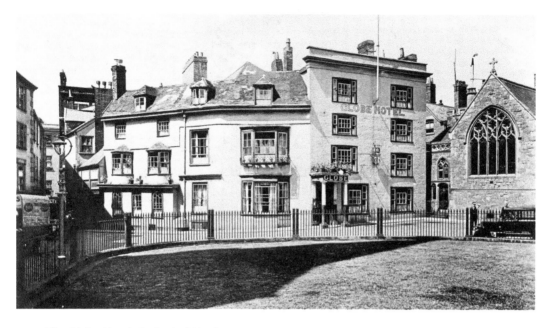

The Globe Hotel, Cathedral Yard, 1930s

This beautiful corner of Exeter survived the Blitz of the night of 4/5 May 1942, but an unseen incendiary bomb smouldered unchecked throughout the following day, eventually claiming the hotel and the adjoining shops. Thankfully, we still have St Petrock's church and the old City Bank Building, which today operate as a centre for the homeless and a shop called Jack Wills (university outfitters) respectively, but otherwise this site now provides access from the cathedral precinct to South Street.

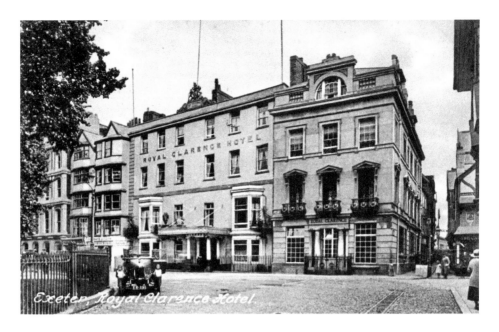

The Royal Clarence Hotel, Cathedral Yard, 1930s

Intended as Assembly Rooms and built in 1768, by 1770 this impressive edifice was being run by Frenchman Peter Berlon as a hotel, using the word in Britain for the first time. Later, a visit by the Duchess of Clarence inspired the name. The part of the building adjacent to Martin's Lane was, from 1769 to 1902, the Exeter Bank; in around 1906 it became Exeter's first Deller's Café. It's now integral to the hotel, which is known as Abode Exeter, run by the Michelin-starred Michael Caines, MBE.

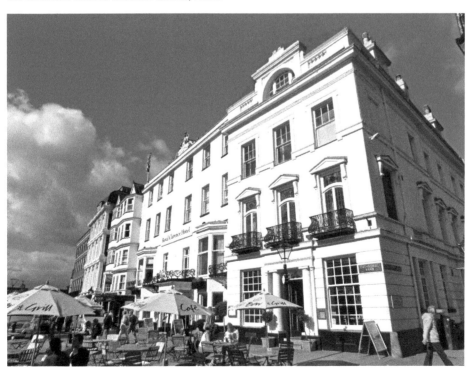

The Law Library, Cathedral Close

This building was originally a canon's house, but after the Reformation tenants were sought among the gentry. The stunning hammer beam roof is one of Exeter's architectural treasures, and dates from the first half of the fifteenth century. Hidden from public gaze until recently, the building being used for decades by barristers and solicitors, this gem is now the Hub On The Green, a thriving community centre with a degree of public access. Knitting, tai chi and baking go on here now, and there's a craft fair every month.

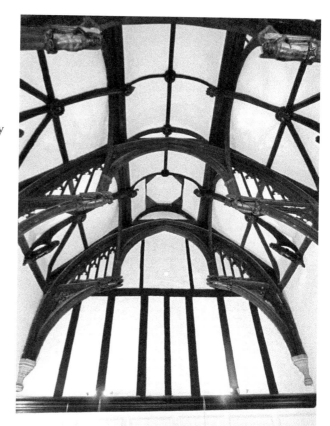

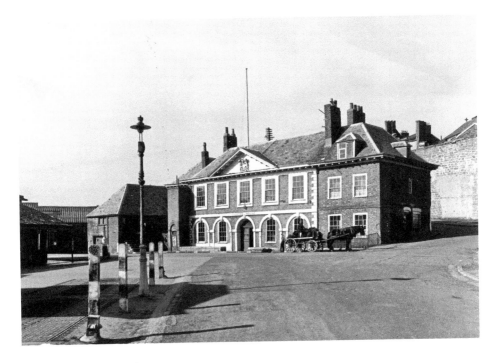

The Custom House, The Quay, 1950s

Built to control the Quay and collect taxes on imported goods, the Custom House was completed in 1681 and is Exeter's oldest extant brick building. It possesses three fine plaster ceilings by the renowned John Abbott of Frithelstock. The inset shows the original crest. Note the cannon, which have never been fired, introduced by the council in 1960. Today, this much loved building houses the Exeter branch of Chandni Chowk, a company that sells clothes and soft furnishings sourced from independent traders in India and Bangladesh.

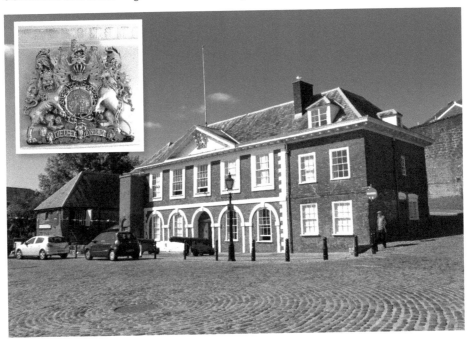

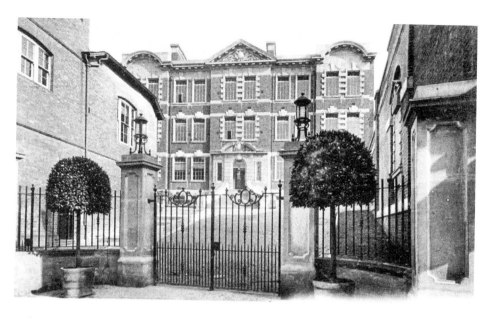

University Extension College, Bradninch Place, Gandy Street, *c.* 1919

By 1903 the University College required more accommodation, so Jessie Montgomery's syndicate acquired Bradninch House. Neighbouring properties were purchased in 1904. Demolition followed, and the site was redeveloped between 1909 and 1911. This neo-Georgian building was to be the hub of college life until 1958. From 1960 the building housed the Exeter College of Art and the Public Health Laboratory Service, the University (by charter of 1955) now maintaining a reduced presence. In 1999 the Phoenix Arts Centre opened, boasting galleries, studios, a theatre, a café and a bar.

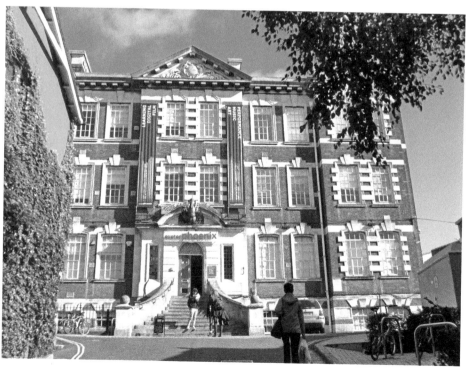

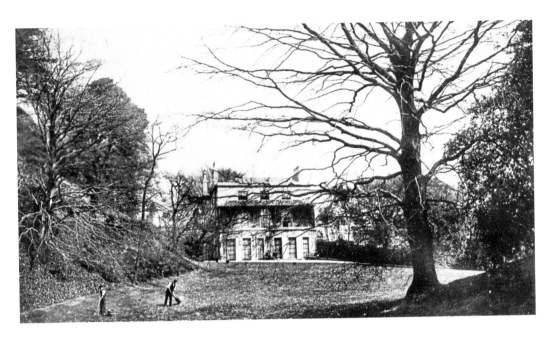

Rougemont House, *c.* 1912

John Patch, a surgeon, built this house in around 1768. A wine merchant called Edmund Granger transformed it in around 1810, adding the Regency refinements we see today. A century later, this house was purchased by the council. In recent times it has been a school, a library, and a part of the museum. In 1987 it became a costume museum. At the time of writing it is empty, and needs resuscitating.

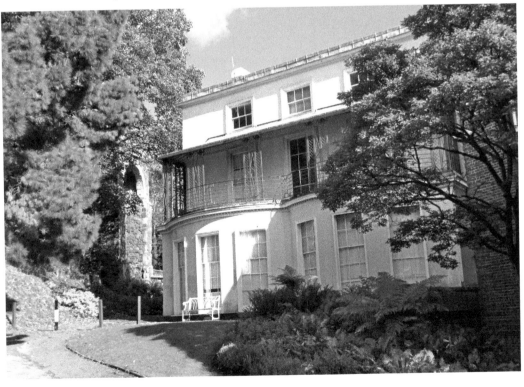

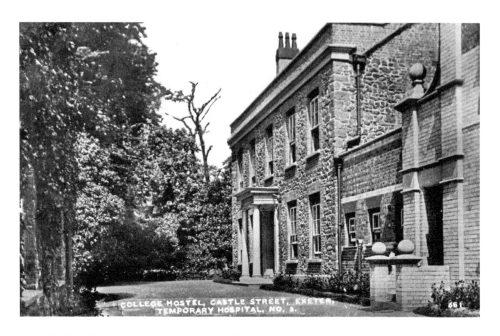

Bradninch Hall, Castle Street, First World War

In 1902 the redoubtable Jessie Montgomery, Secretary of the University Extension Committee (1888–1918), formed a syndicate and bought a property called 'The Vineyard' in Castle Street. This became College Hostel and accommodated thirty female students. Miss Montgomery lived here as warden for the first two terms. In 1915 it became a military hospital, returning to College control in 1919. By 1933 it had become unsuitable and was sold to the city council. Now it provides office space for private companies and the Workers' Educational Association.

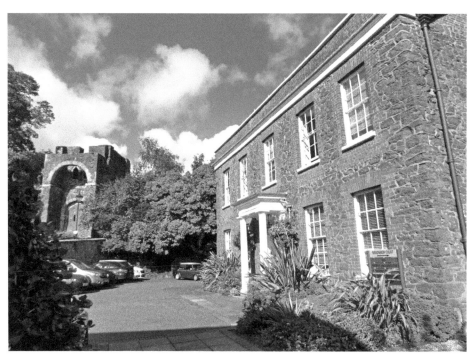

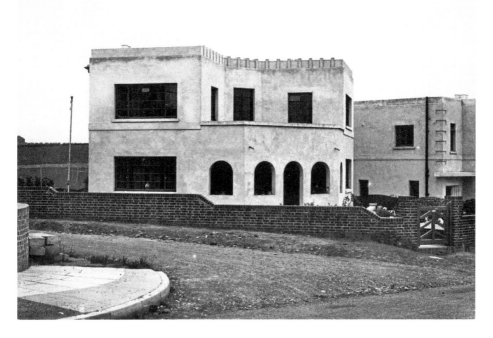

Art Deco Houses, Sweetbrier Lane and Whiteway Drive, 1933–36

These houses, so very different from the housing stock that surrounds them, were built in stages between 1933 and 1936. The forward-thinking architect designed them with garages integral to their frontages, such was the ever-growing influence of the motor car. Now that the buildings have matured, they sit rather well in the landscape, and Heavitree would be the poorer for their absence. The clean lines appeal to minimalists and fans of the Art Deco period, and these unusual houses are much sought after.

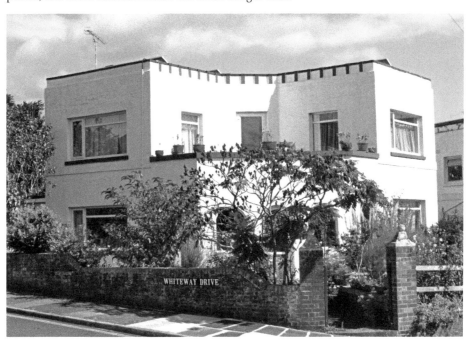

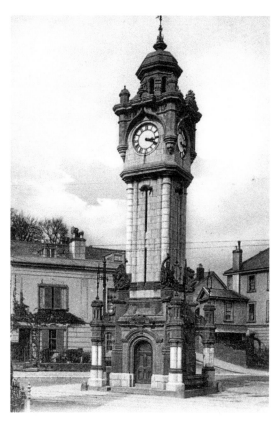

Queen Street Clock Tower, *c.* **1930**
Properly known as 'The Miles Memorial
Drinking Fountain and Clock Tower', this
landmark started off in 1877 as a horse
trough and obelisk. It was financed by
William Miles, a local philanthropist
and equine enthusiast. He died in 1881.
Later, and with Queen Victoria's Diamond
Jubilee approaching, Miles's widow
decided to both create a lasting memorial
to her husband and commemorate the
Jubilee. It was built in Jubilee year and
unveiled in 1898.

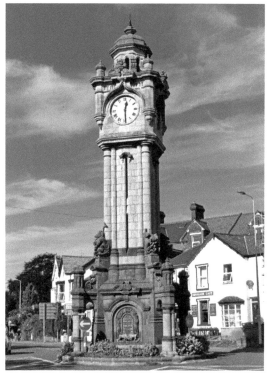

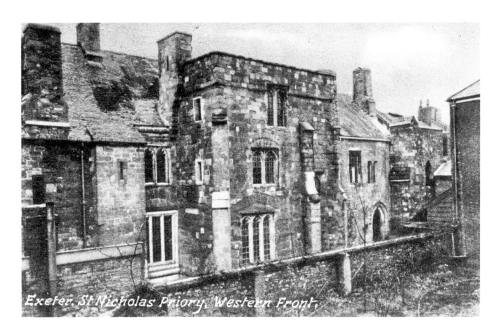

Exeter, St Nicholas Priory, Western Front,

St Nicholas Priory, Mint Lane

Hidden away behind Fore Street is the surviving part of a Benedictine monastery, believed to have been founded in 1087. There may be no older standing building in the whole of Devon. It was, however, the first monastic community in Exeter to be dissolved by Henry VIII, in 1536, and thereafter became a town house for a succession of wealthy locals. Since 1913 it has been a museum, and now offers a wonderful, colourful insight into domestic arrangements in Tudor times.

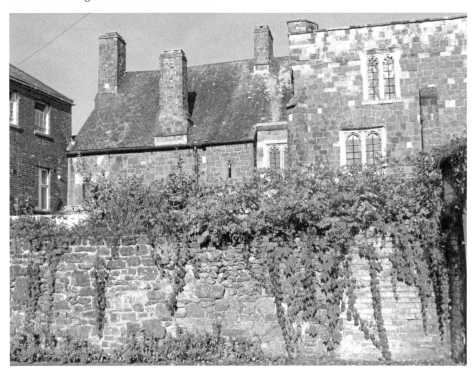

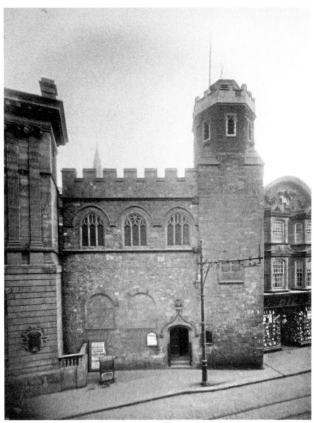

St Petrocks Church, High Street, 1914

There is no documentary evidence earlier than the twelfth century for this wealthy church, but given its central location, adjacent to the town's main crossroads, it is likely to be older. Historically charitable towards the poor, it is appropriate that, since 1995, it has operated as a day centre for the homeless. In addition, the church has become a training centre for bell-ringing, the extremely light peal attracting interest from all parts of the country.

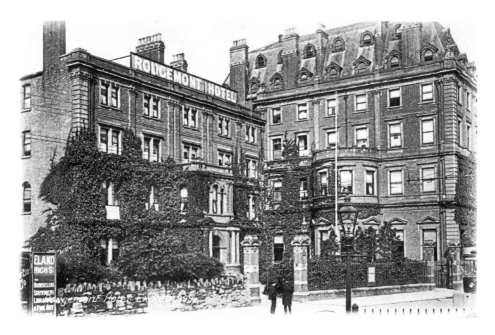

Rougemont Hotel, Queen Street, 1920s

This exuberant building was erected on the site of the Exeter Borough Prison, which closed in 1863, and was completed in 1879. Directly opposite Central Station, it was developed to provide accommodation for the ever-growing number of rail passengers now regularly travelling to and from London. Happily, the reception rooms are largely unaltered, and they enjoy a hushed, restrained atmosphere that the Victorians would recognise. Renamed as the Rougemont in 2008, after a dalliance with corporate branding, this attractive building remains one of Exeter's leading hotels.

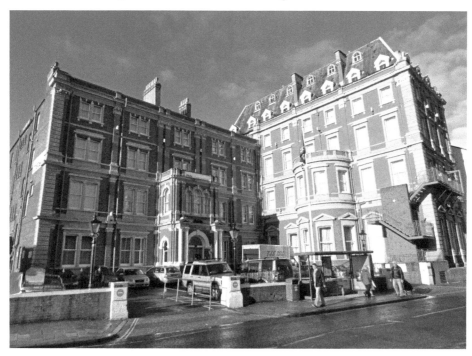

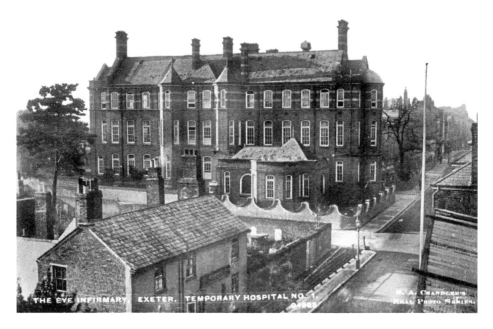

The West of England Eye Infirmary, Magdalen Street, First World War

There has been an eye hospital in Exeter since 1808. First located in Holloway Street, it moved to Magdalen Street five years later. Between 1899 and 1908 the building shown here was constructed in stages, and continued its good work until 1992. More recently it has been used by the hospitality industry, the Hotel Barcelona opening in 2001 before closing in 2008 for refurbishment. Reinvented as the Magdalen Chapter, this appealing property now offers open fires, a library, peaceful gardens and a pool. The inset shows the eye infirmary's visiting hours, on a board which still hangs in the hotel.

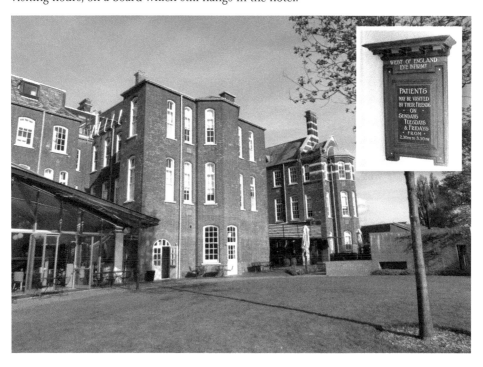

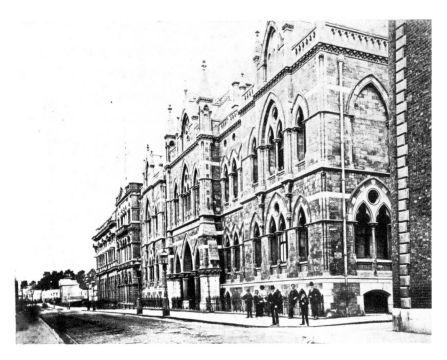

The Royal Albert Memorial Museum, Queen Street, 1880s

Following the death of Prince Albert in 1861, an Exeter MP, one Richard Somers Gard, donated a site in Queen Street to the city, and a competition was held to design a suitable memorial to the prince; this starting edifice, so unlike anything else in Exeter, was the result. After a major refurbishment between 2007 and 2011, we now have an award-winning museum in the very heart of the city which even incorporates part of the Roman wall.

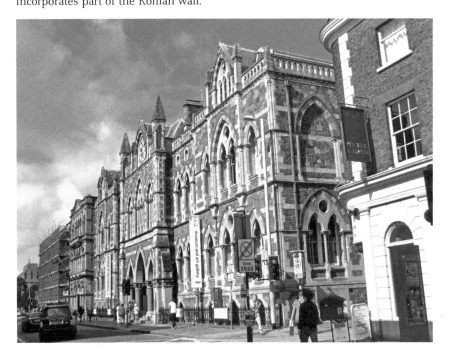

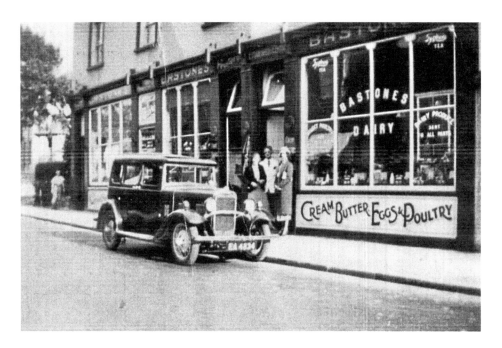

Bastones Dairy, 36 Magdalen Road, St Leonards, 1930s

The Bastone family ran their dairy, poultry, fruit and flowers business from No. 36 Magdalen Road for about fifty years, having moved from No. 4 in around 1895. At times, they expanded into No. 38. For some years after transferring the premises to another grocer, Mrs Bastone continued to live nearby. Today, this road is much busier and parking here would be impossible. We currently have Gibson's Plaice (fish shop), Duo (interior design), and a sandwich and coffee bar, the Sandwiched-Inn, in occupation.

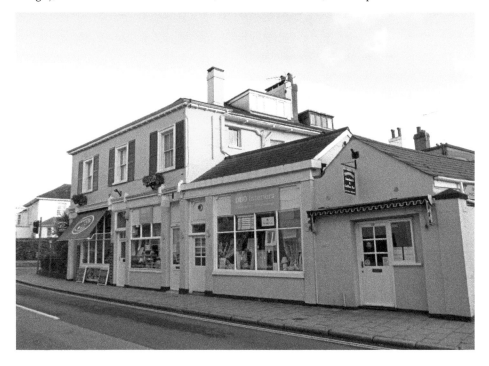

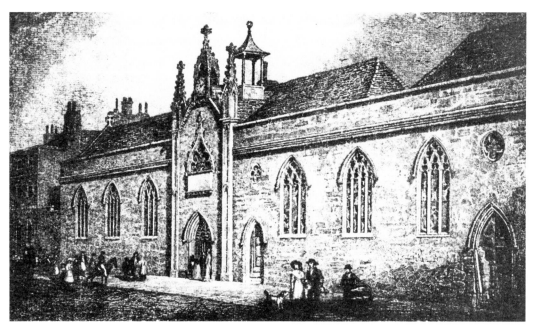

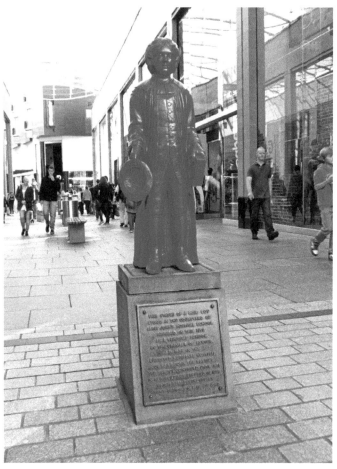

St John's Hospital School,
High Street & Princesshay
Formerly a hospital
dedicated to St John
the Baptist, after the
Dissolution of the
Monasteries this building
became a boys' grammar
school. The uniform of
blue caps and gowns led
to the pupils' nickname
of the Blue Boys; one
fondly remembers the
Blue Boy Gift Shop in the
old Princesshay. Today,
the statue pictured here,
located on the site of the
school, is the only visible
reminder we have after the
school closed in 1931. All is
not lost, however – Exeter
and St Peter's schools are
both descendants.

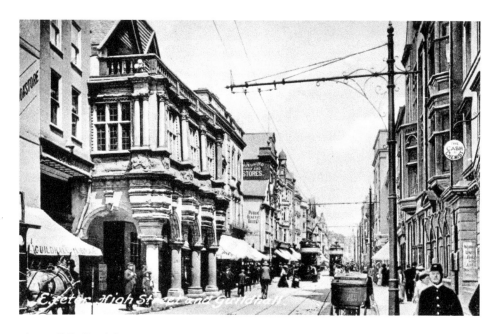

The Guildhall, High Street, c. 1910

No other city in the country has a civic building of greater antiquity than Exeter. The Guildhall has been in continuous use since 1160; the present building dates to the fifteenth century, with later additions. All manner of public affairs have been settled here, local justice has been meted out, and the city records have been stored within these walls. Now, this venerable building is the focal point for mayoral functions and royal visits. The Council Chamber is used for exhibitions, and one can even get married here. The inset shows the mayoral chain, designed by William Burges in 1874, while in Devon working on Knightshayes Court, near Tiverton.

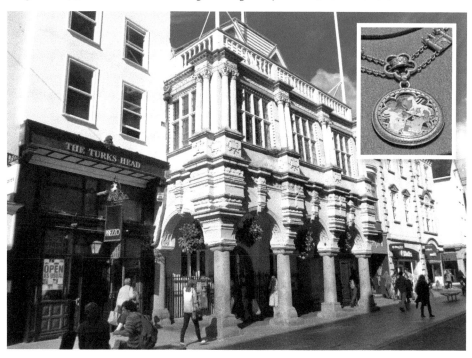

Rougemont Castle, Castle Street, *c.* 1911

For centuries, the castle has acted, in part, as a court. The Sessions House of 1607, located in the inner bailey of the castle, was replaced in 1773 by the existing courthouse. Built of limestone, it was designed by Philip Stowey in the Palladian style. Today, with the lawyers rehoused elsewhere, this splendid edifice is a mixture of homes, offices and function rooms. Weddings are celebrated here, and the courtyard regularly hosts food festivals and Shakespearean productions. Revellers beware: the cells still exist...

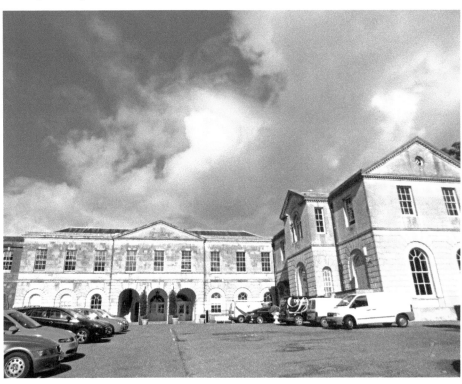

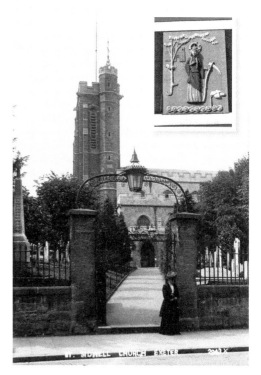

St Sidwell's Church, Sidwell Street, *c.* 1910
Even though situated outside the city wall,
St Sidwell's was appointed a parish church in
1222. It is located at the spot where St Sidwell
was buried after being beheaded, probably
in the seventh century. Apparently, water
issued forth from the spot where her head
fell, and sainthood for this Saxon farmer's
innocent daughter duly followed. The church
was rebuilt, in 1957–58, of brick and concrete,
and is today a mixture of chapel, homes,
and community centre. The inset shows a
sculpture of St Sidwell which is affixed to a
nearby building.

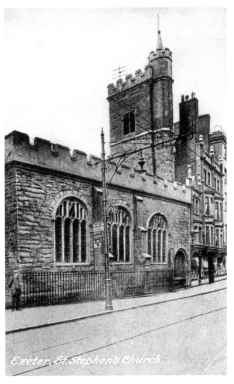

St Stephen's Church, High Street, 1920s
Squeezed in between the shops of the High
Street is the charming church of St Stephen.
Mention is made of a church on this site in
the Domesday Book, although the present
building dates from 1664, with later neo-Gothic
remodelling. A most picturesque feature
is St Stephen's Bow, an arch under which
generations of Exonian children have played;
it was originally a chantry. The church has
recently been refurbished to a high standard,
and is now suitable for present-day worship and
community use.

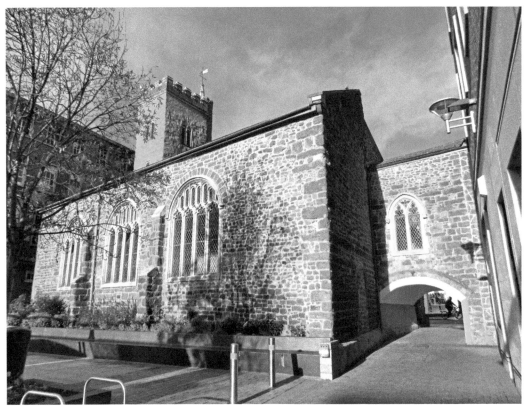

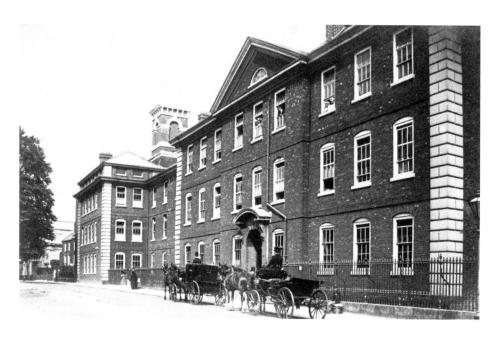

Royal Devon & Exeter Hospital, Southernhay East

In 1741 Dr Alured Clarke, Dean of Exeter, founded the Devon & Exeter Hospital in Southernhay. The city's main hospital until 1974, it was granted royal status by Queen Victoria in 1899, following a visit by the Duke and Duchess of York. Does this photograph show royal visitors? Note the interested spectators at the second-floor windows. At the time of writing this enormous building is being redeveloped; Dean Clarke House, as it is now known, will soon be a mixture of homes, shops and cafés.

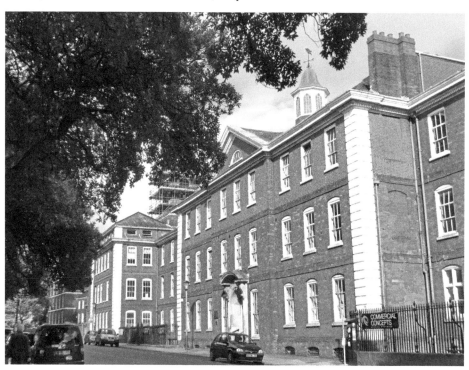

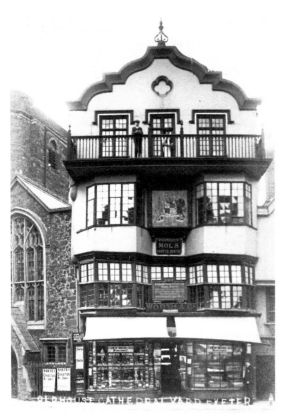

Mols Coffee House, Cathedral Close, c. 1920

Built by the cathedral as part of the Annuellars College, this quirky building acted as Exeter's Custom House from 1595 to 1660. In 1726 one Mary Wildy opened a coffee house, inspiring the name that endures to this day. In 1878 Worth's started producing their famous postcards here, the business operating until 1958. From 1997 to 2006 Eland the stationer's traded from here, but the current occupier is Cadastre, a luxury leather goods specialist.

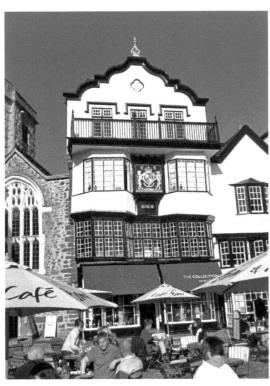

George's Meeting, South Street, Post-Second World War

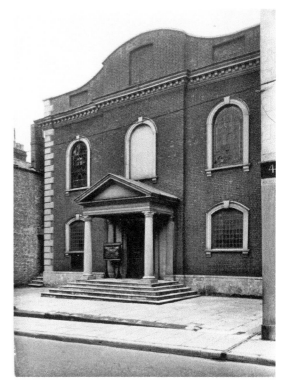

Considered by Pevsner (a leading commentator on English architecture) to be 'a fine complete example of its type', and now Grade I listed, George's Meeting was founded in 1760 as a unitarian chapel. The beautiful brick façade and the Tuscan porch make a bold architectural statement in a street with three other places of worship. Named after King George III, it was used for prayer until 1987; thereafter the building became 'Global Village', selling goods from around the world. It has been a Wetherspoon's pub since 2005.

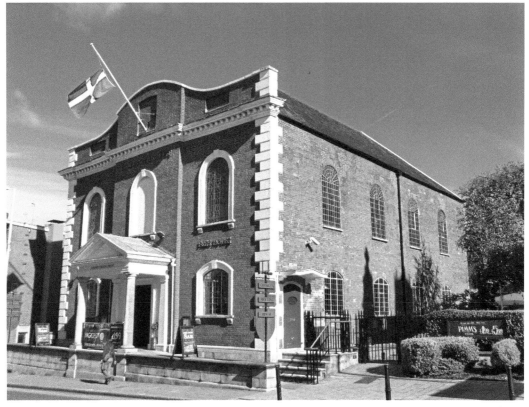

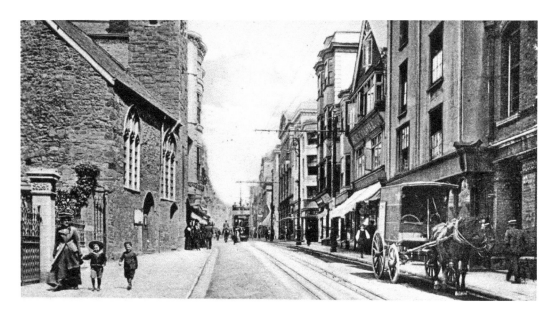

St Olave's Church, Fore Street, *c.* 1908

It is believed that King Harold's mother, Gytha, founded this church in the eleventh century. It was rebuilt and extended in the fourteenth century, obliterating much early work, and put at the disposal of refugee Huguenots in 1685, enabling them to conduct services in French. This they did for seventy years. Restoration in 1874 included the installation of the font and the pulpit that we see today. Occasional services are held in this ancient and attractive church.

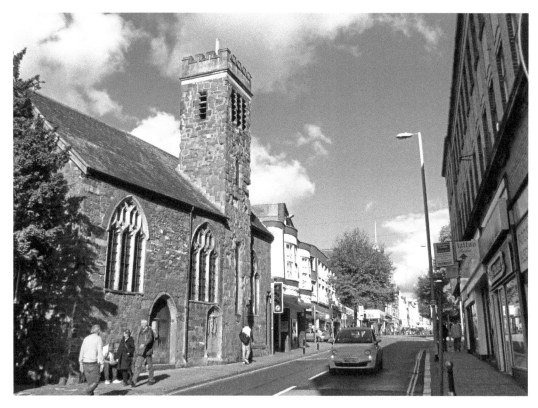

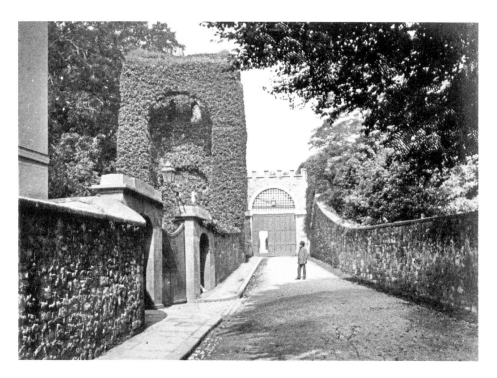

The Gatehouse, Rougemont Castle, 1880s

The citizens of Exeter were opposed to King William and, after an eighteen-day siege in the autumn of 1068, it was deemed necessary to reinforce his authority. Forty-eight houses were destroyed, in a show of strength, to make way for a castle. It was placed strategically just inside the existing city wall, and may well be Britain's earliest stone castle. Today's romantic ruin must surely at one time have sent out a compelling message of monarchical military conviction.

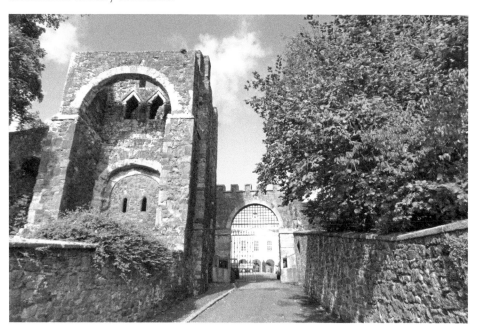

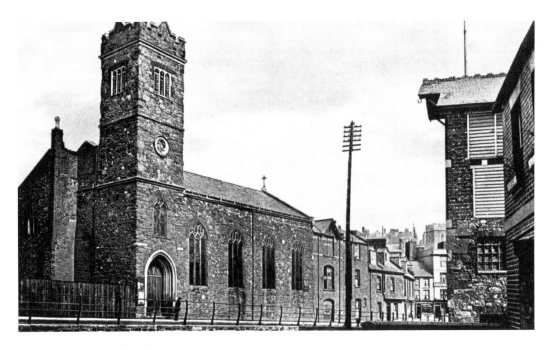

St Edmund's Church, Edmund Street, *c.* 1910

This is the first stone bridge built over the Exe, aligned to give an unavoidable view of the mighty cathedral. The church is contemporaneous. Constructed around 1230–40 by the Mayor, Walter Gervase, the bridge was in use until its replacement was completed in 1778. Today this enormously important medieval site is landscaped and one can appreciate the scale of the structure, as eight arches remain. Of the church, rebuilt in 1834, only the tower survives.

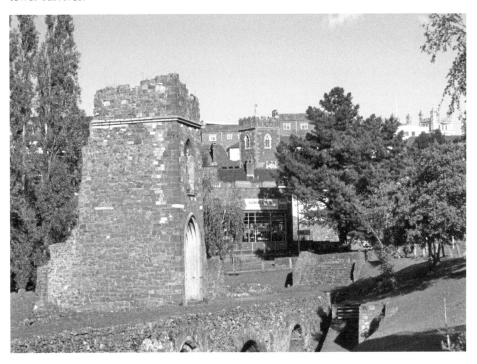

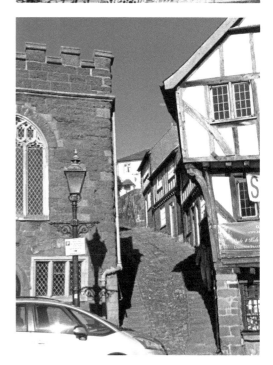

Stepcote Hill, *c.* 1910

Having approached Exeter from the west, across the bridge, a medieval traveller would have been confronted by the West Gate (demolished in 1815) and then Stepcote Hill. This steep, cobbled street was once an important thoroughfare, lined with merchants' houses. A pair of these remains at the bottom of the hill; they were restored in the 1930s, having been threatened with demolition. Today, all is peaceful and picturesque, the hill too steep for most, but what stories the cobbles could tell.

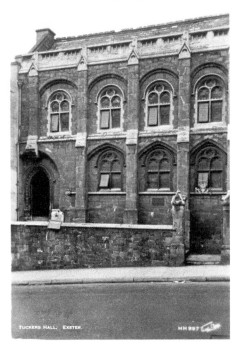

Tuckers' Hall, Fore Street, 1940s

Partly an orchard, the site of Tuckers' Hall was a gift from William and Cecilia Bowden to Exeter's weavers in 1471. A guild chapel was built, and in 1620 a royal charter was granted by King James I. A school for members' sons from 1675 to the early twentieth century, the building is still used by the Guild, and is sometimes open to the public. Visitors are rewarded with a fine original wagon-roof, seventeenth-century oak panelling, and a display of trade implements.

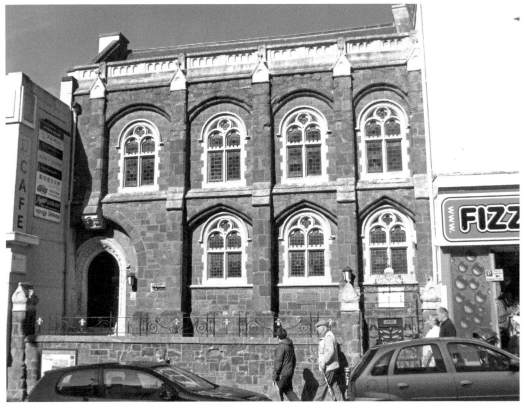

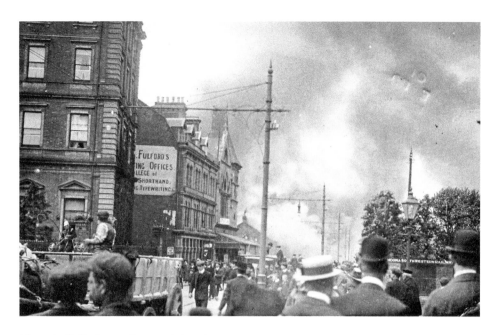

Victoria Hall, Queen Street, 6 October 1919

In 1868 it was decided that Exeter needed a general purpose performance venue, and in due course Victoria Hall was built. In October 1896 it showed the city's first moving film, and by 1910 was known as the Victoria Hall Picture Palace. Disaster struck on 6 October 1919, however, when fire took hold, breaking the windows of the neighbouring Rougemont Hotel and gutting the hall. The site was redeveloped for Rowe Bros. & Co., builders' merchants, and the site is now occupied by Victoria House, part of Exeter College.

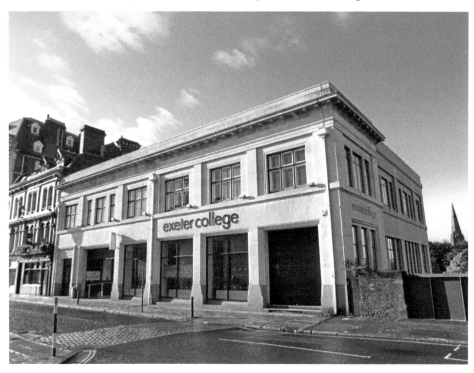

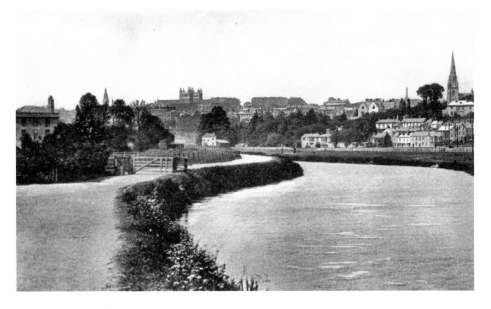

Exeter Canal

Legend has it that, upset by the Mayor in 1284, the Countess of Devonshire (from the Courtenay family of Topsham) blocked the Exe by building a weir, denying the city access to vital trade routes. An Act of Parliament in 1539 authorised the building of a canal and in 1563 John Trew started construction. It was the first pound lock canal in England. Now a recreational amenity rather than a bustling trade link, the waterway is used for boating, fishing, walking and birdwatching.

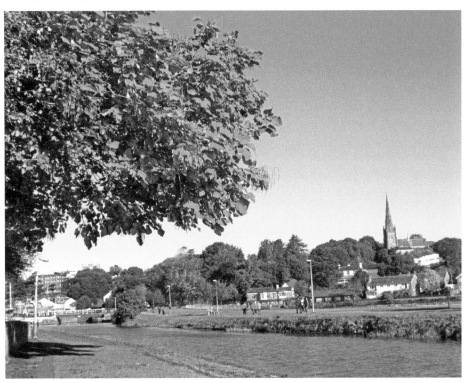

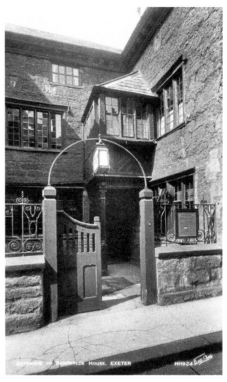

Bampfylde House, Bampfylde Street, 1930s
Catherine Street used to meet Bampfylde Street and at this corner stood Bampfylde House. Built by Amyas Bampfylde (of Poltimore) from 1590, it stayed in the family until just after the First World War. After various commercial usage the house was acquired by the council for £5,000, and was opened to the public in 1934. This provided a wider audience for the sumptuous interior – a treasure trove of panelling, stained glass and decorative plasterwork. This Elizabethan jewel was destroyed during the Blitz and its site is now part of the Princesshay development.

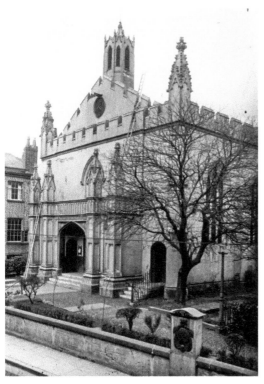

Holy Trinity Church, South Street, Post-Second World War

The medieval church that once occupied this site was demolished, along with the adjacent South Gate, in 1819. A year later, the Incorporated Church Building Society erected Holy Trinity church. It remained a place of worship until 1968. The premises were taken over in 1977 by the Exeter White Ensign Club, an organisation that has affiliations with the Royal Marines Association. The club was formed in 1947 to support current and ex-marines. 'Trinity House' is open during the evenings and some lunchtimes.

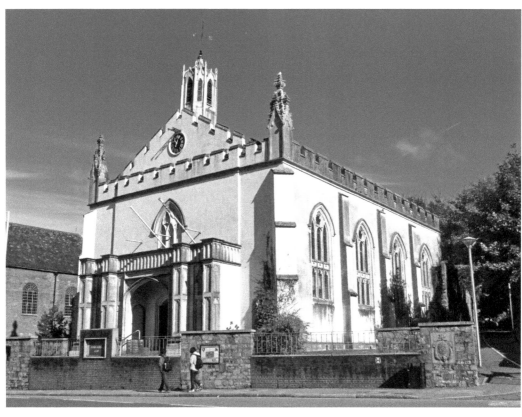

The Tudor House, Tudor Street, c. 1905
This stunning timber-framed building is of uncertain date, although English Heritage (who refers to it as 'Tiddy House') considers it to be of late sixteenth-century origin. It was an electrical repair shop in 1964, when one Bill Lovell bought it, and it was in a parlous state; several years and a great deal of money were spent on saving it. Mr Lovell's achievement was rewarded with a Civic Trust Award and a European Heritage Award. In 1994 it was converted from a restaurant to a spectacular private dwelling.

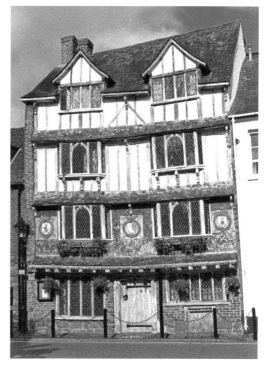

EXETER TUDOR HOUSE

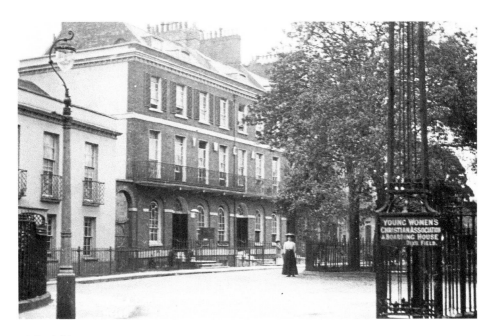

Dix's Field, c. 1910

Built by renowned Devonian architect-builder Matthew Nosworthy in the first quarter of the nineteenth century, this architectural delight was laid out as two fine terraces facing a green. Nosworthy himself lived here, as did the Revd Sabine Baring-Gould. Severely damaged during the war, restoration of these important buildings was recommended. Today, however, we have the Civic Centre, a car park, Sterling House and Penny's estate agent's. At one end of Dix's Field is Southernhay United Reformed church, which has a rather elegant listed spire.

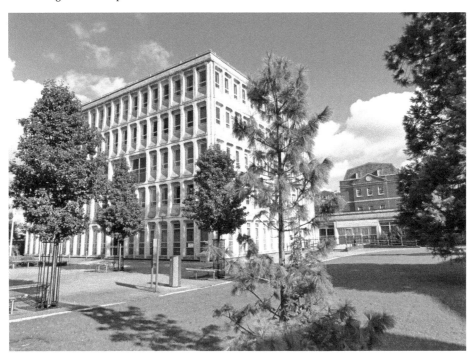

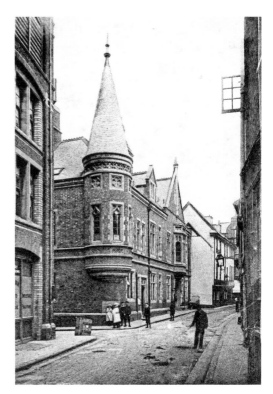

Exeter City Police Headquarters,
Waterbeer Street, *c.* 1908

Roman mosaic pavements were discovered
while building the police station in 1887,
and were incorporated into the new
structure, which was located between the
Guildhall and St Pancras church. The force
moved to Heavitree Road in 1960. This
area is now a raised garden of trees and
shrubs, and is the home of a sculpture
entitled *Looking Forward*, a bronze by local
artist Peter Thursby, which was erected to
commemorate the Silver Jubilee of
HM Queen Elizabeth II in 1977.

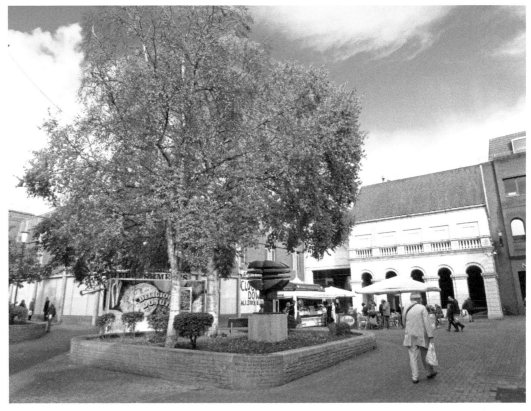

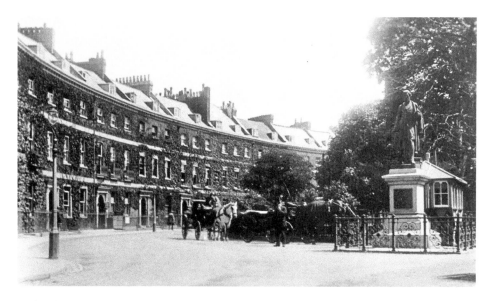

Bedford Circus, 1909

The former site of a Dominican monastery, Bedford House was demolished in 1773. Enter Robert Stribling, cathedral carpenter, who began to develop what was to become his masterpiece. An elegant, elliptical development of town houses and a church, overlooking a stand of trees, Bedford Circus was completed in 1826 to universal acclaim. Many of the frontages survived the Blitz, but the circus was demolished by the council; today the northern end of Princesshay occupies this once beautiful site.

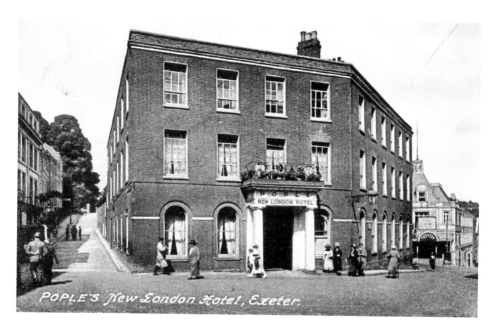

POPLE'S New London Hotel, Exeter.

New London Inn, London Inn Square, *c.* 1934

In 1793, legendary publican John Land began rebuilding the Oxford Inn, with Matthew Nosworthy's help, reopening as Land's New London Inn during the summer of 1794. An important coaching inn, it served London, Falmouth, Bristol, Bath and Plymouth. In 1868 the business was bought by Robert Pople, and it became Pople's New London Hotel. The building was demolished in 1936 and rebuilt as the Savoy Cinema, later the ABC Cinema. Today we have Brittany House, the offices of Working Links and the St Loyes Foundation.

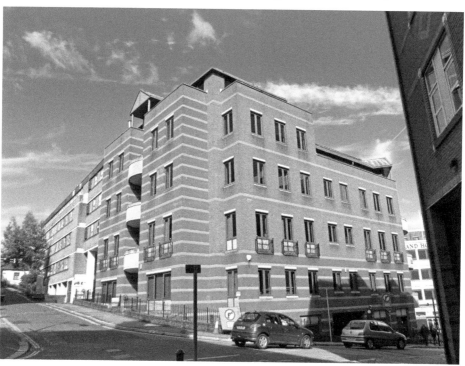

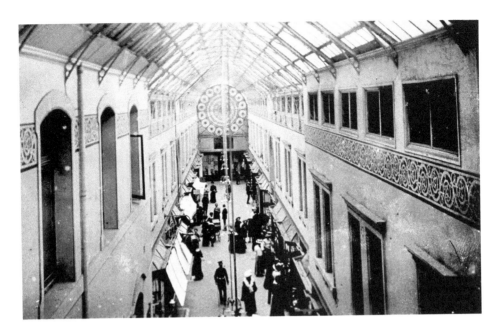

East Gate Arcade, High Street, *c.* 1909

This elegant glass-roofed shopping arcade, with its distinctive circular stained-glass window, was built in 1882, and lasted until the Blitz. Twenty-two shops occupied the arcade, which was often decorated with flowers. The Temperance Hotel stood at the northern end, fronting the High Street. Tenants included Melhuish's Art Furnishers, S. A. Chandler (a photographer), and, bizarrely, the Western Counties Antiseptic Toilet Club! Today, approximately on the site of the arcade, in Princesshay's Eastgate, we have Zara, Hotel Chocolat and the Carphone Warehouse.

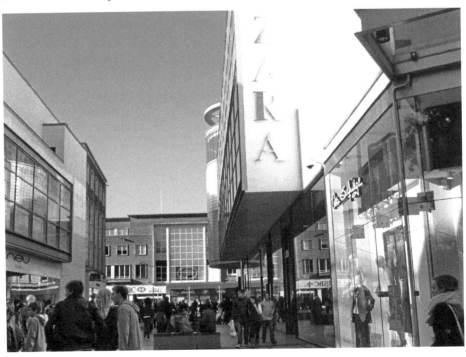

Paul Street, *c.* 1937

In the nineteenth century, Mr Trueman ran a boys' school in Paul Street. Between 1878 and 1924 the building was the South Western Hotel. It was demolished to create a bus station here, until Paris Street was developed in 1964. A friend fondly remembers the spiral staircase in the waiting room, and Dellers Cafeteria opposite. Devon General, Royal Blue and Greenslades operated from here. A car park after 1964, today we have Multiyork, Panasonic and HQ Hair Design, among others, in the Harlequins Shopping Centre.

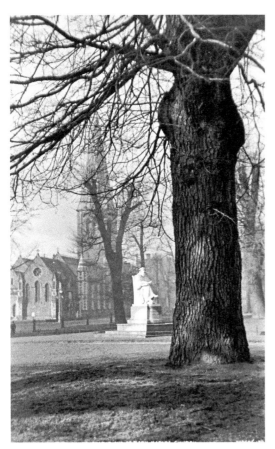

Richard Hooker & St Mary Major Church, Cathedral Green, *c.* 1900

A theologian of immense significance to the Anglican Church, Richard Hooker (1553–1600) was the influential scholar who wrote *Of the Laws of Ecclesiastical Polity*. His statue rightly sits on the cathedral green. The eleventh-century church of St Mary Major once adorned the green, too, but was rebuilt around 1865–68. Seen here behind Hooker, this Victorian building was pulled down in 1971, revealing the important remains of a Roman bath house complex. The statue was moved a few feet in 2011, during improvement works.

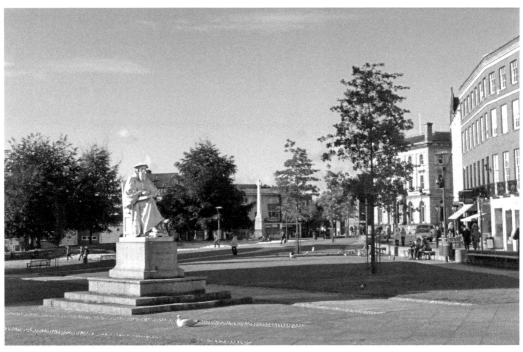

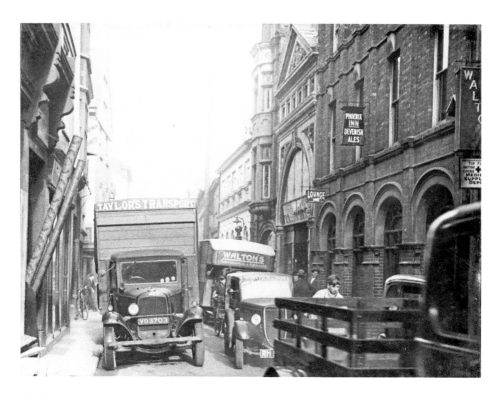

Goldsmith Street, c. 1938

Named after the craftsmen who once worked in this ancient thoroughfare, Goldsmith Street is documented to 1291 and may be older. Previously running from the High Street to Paul Street, it had churches at either end – Allhallows until 1906 and St Paul's until 1936. You may remember the Phoenix Inn, subsumed by Waltons in 1956. All that remains of Goldsmith Street is one of the entrances to Higher Market, completed in 1838, and today adjacent to W. H. Smith in the Guildhall Shopping Centre.

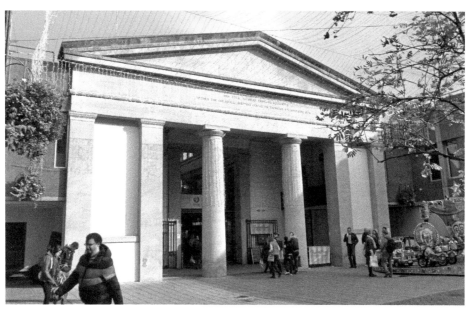

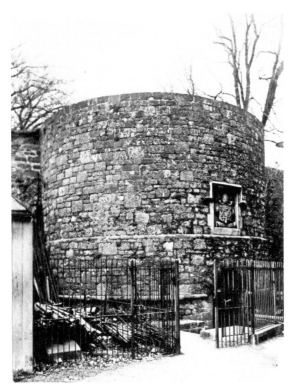

The Bishop's Tower, Little Southernhay Lane, *c.* 1950
Sometimes known as Lollard's Tower or Prison, this is where prisoners of John Wyclif were incarcerated. Today it can be found between the Southgate Hotel and the Bishop's Palace. It is part of the wall, around 2,600 yards long, which the Romans built in around AD 200 and that defined the city's limits well into the nineteenth century. Exeter's largest structure, it can still be appreciated in several locations, including the museum where it has been incorporated during the recent redevelopment.

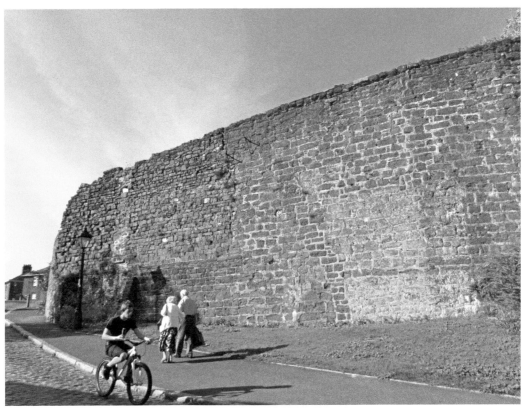

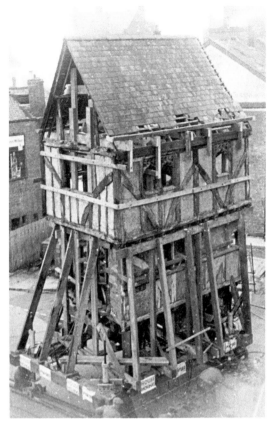

The House That Moved, West Street, 12 December, 1961

This well-known tourist attraction was uprooted in 1961 from Frog Street, and relocated to West Street. Frog Street was being demolished to make way for the inner bypass but this house, at least, was considered worth saving. Pevsner refers to it as 'the best half-timbered sixteenth-century house of Exeter'. Today it sits beside the remains of West Gate and, together with St Mary Steps church and a pair of merchants' houses opposite, forms a most picturesque group.

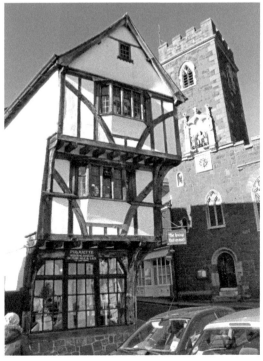

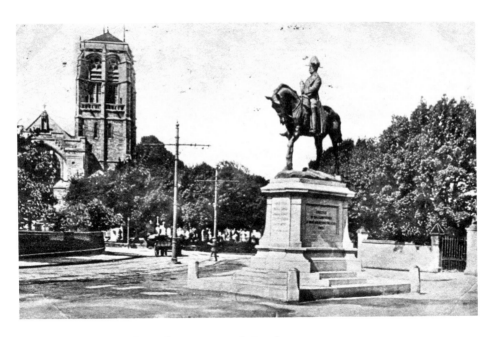

St David's Church & The Buller Statue, Hele Road, *c.* 1910

After winning an architectural competition, W. D. Caroe built St David's church between 1897 and 1900. Caroe had previously worked on Truro Cathedral and produced here a confident, lively place of worship. Today it stands across Hele Road from Exeter College. General Sir Redvers Buller, of Crediton, enjoyed a successful military career, winning the Victoria Cross in 1879. The bronze statue, erected in 1905, was paid for by public subscription, and is by Adrian Jones. Unusually, the subject witnessed the unveiling.

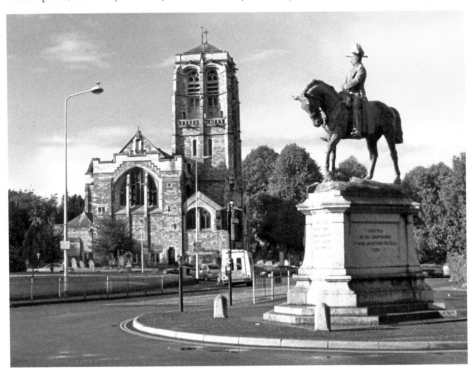

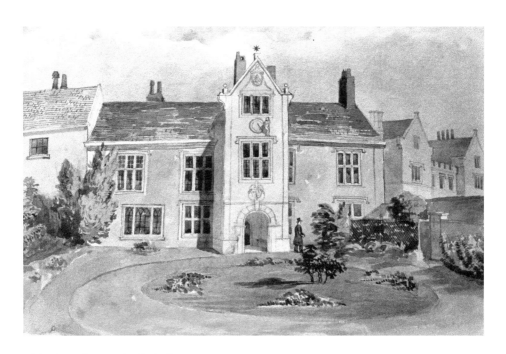

Abbot's Lodge, Cathedral Close, 1870s

Believed to be the only building in Exeter completely destroyed by a high explosive bomb in the Blitz, this attractive Heavitree-stone building once stood in Cathedral Close, behind what is, today, No. 12. It was the town house of the Abbots of Buckfast during the fifteenth century, and after the Dissolution it was granted to the Rolle family, who remained for nearly 200 years. Sir John Rolle entertained the Grand Duke of Tuscany here in 1669. The artist is unknown, but the painting is inscribed 'Mr Dawsons and Canon Cooks'. These gentlemen were known to reside here in 1878.

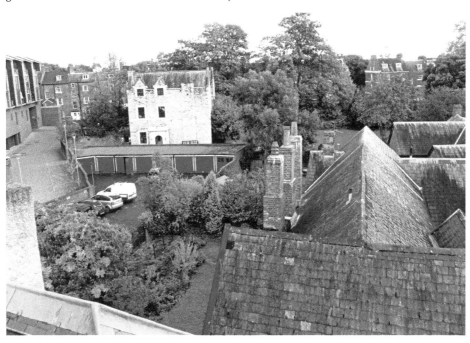

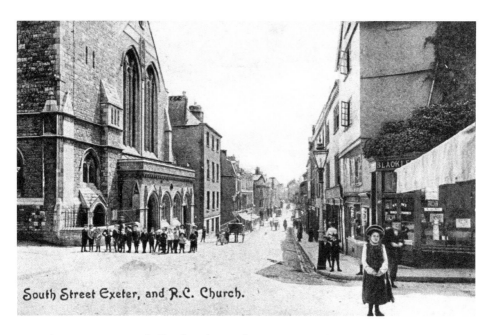

South Street Exeter, and R.C. Church.

Sacred Heart Roman Catholic Church, South Street, c. 1906

Built around 1883–84 by Leonard Stokes and Charles Ware, this church occupies a difficult sloping site that once housed the Abbots of Tavistock. The interior is a sumptuous affair, which makes use of a variety of local stone including that of Beer, Bath, Portland and Pocombe. The adjoining presbytery has recently been restored. The charming earlier photograph has perhaps captured a Sunday school outing and it has a different feel to the present day, due in part to the road being widened in 1958.

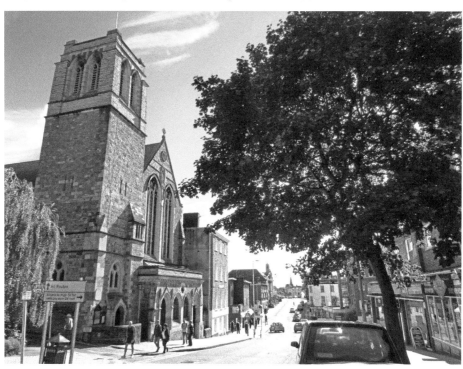

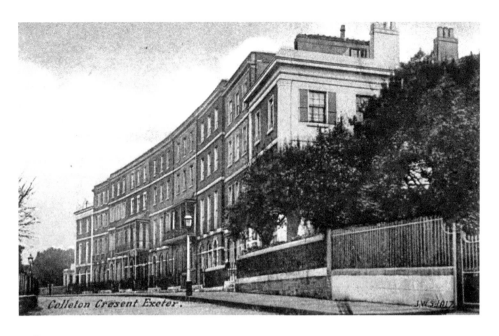

Colleton Crescent, 1924

Built by Matthew and Thomas Nosworthy between 1802 and 1814, this fine Regency terrace commands tremendous views of the River Exe and the Haldon Hills beyond. It is named after a local family of merchants and was immortalised by J. M. W. Turner in his *A View of Exeter*; the Crescent has also appeared in *The Onedin Line* and *The Hound of the Baskervilles*. Now occupied mainly by solicitors, accountants and property companies, some original internal features remain, such as staircases, plasterwork and panelling.

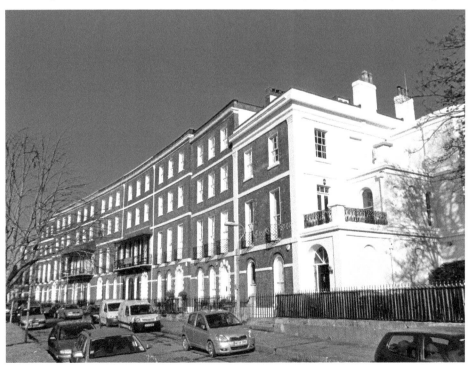

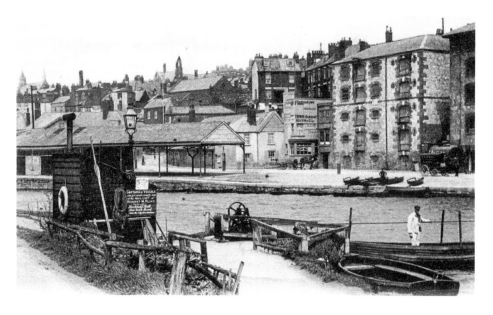

Butt's Ferry, The Quay, *c.* 1880s

Pedestrians have been ferried across the River Exe since the seventeenth century. Rowing boats used to provide the service, as David Rees describes in *The Ferryman*, a novel about the cholera outbreak of 1832; now, a strong wire rope is used to draw the ferry across the water by hand. There used to be a ferryman's cottage on the Quay. Thanks to public outrage and the intervention of Mr George Butt in the 1970s, the service was saved from being scrapped.

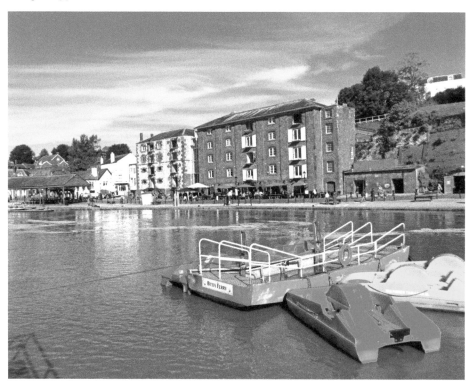

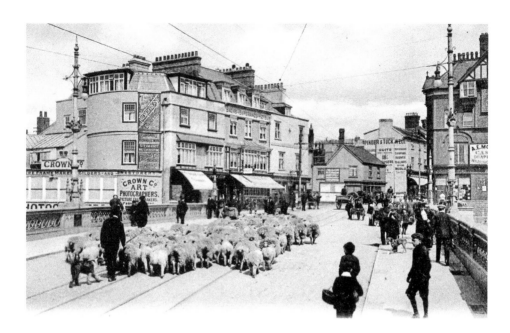

New Bridge Street, *c.* 1908

Work started on a new river crossing in 1770 and, after storms delayed progress, the three-arched stone bridge was completed in 1778. New Bridge Street was built, aligned with the new bridge, to connect it to Fore Street. The bridge was demolished in 1903, and its successor opened in 1905. Made of steel and cast-iron, this one enabled the trams to run to St Thomas and Alphington. In 1969 and 1972 two new bridges were built, and the elegant Edwardian structure was demolished.

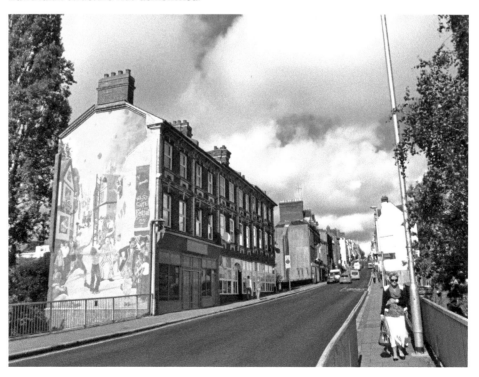

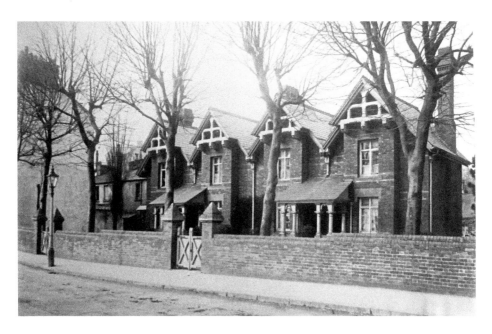

St Petrock's Almshouses, Magdalen Street, *c*. 1914

Erected in 1879 by the wealthy trustees of St Petrock's church, these attractive almshouses replaced those of Cornish's Court – which no longer exists – in Paul Street. An adjoining garden was earmarked for further development, but this now lies under Western Way. Built on a steeply sloping site, the rear view of these apparently two-storeyed houses shows, in Pavilion Place, basement-level accommodation. The properties were upgraded in 1945 and again in 2011; the gable decoration has now gone, as have the trees.

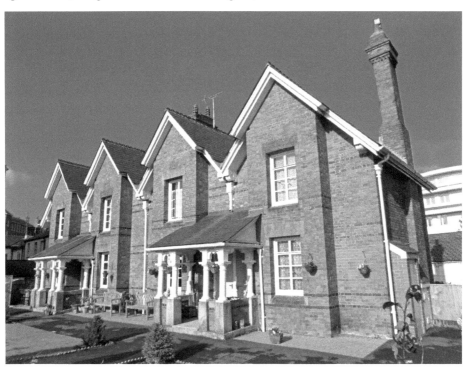

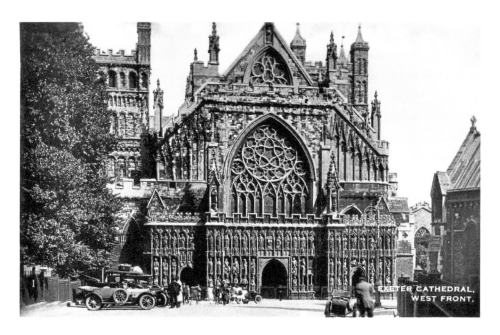

The Cathedral Church of St Peter, 1920s

William the Conqueror's nephew, William Warelwast, was Bishop of Exeter from 1107 to 1137. He replaced the existing Saxon cathedral with his own, but only his towers remain. It was a later bishop, Walter Bronescombe (1257–80), who gave us the world's longest unbroken span of Gothic fan vaulting. John Grandisson, bishop from 1327 to 1369, oversaw the development of the west window and the sculpture screen, dying six years before the completion of this awe-inspiring building. The Bishop's Throne, the thirteenth-century misericords, the contents of the library, and the seventeenth-century organ are all deserving of thorough inspection.

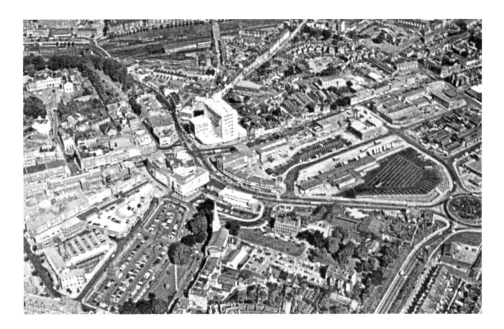

Bobby's, Sidwell Street, 1960s

In 1922 F. J. Bobby bought the premises of Green & Sons, and opened a ladies' fashion shop. The business expanded, and by the 1930s occupied premises either side of St Stephen's church. After suffering bomb damage in May 1942 the company moved to Fore Street. In 1963, Bobby's, by now owned by Debenhams, moved into new premises on the corner of Sidwell Street. It was renamed as Debenhams in 1973, and in 2012 this landmark building reopened as a John Lewis store.

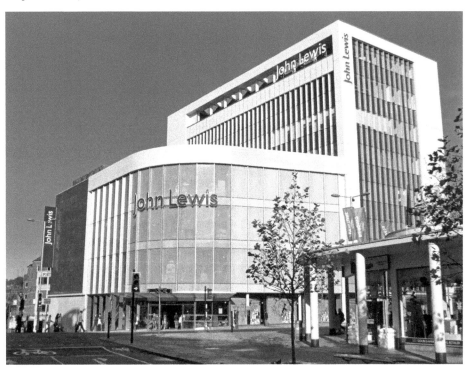

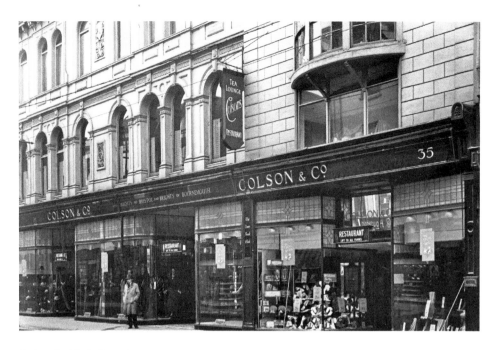

Colson's, High Street *c.* 1935

There is a listing as early as 1835 for Colson & Spark, Linen Drapers, at No. 34 High Street. By 1878 this had become Colson & Gates, Outfitters, Drapers and Furriers, now occupying Nos 33 and 34. By 1887 the company had become Colson & Co. By 1903 the business had expanded into No. 32, and by around 1921 had taken over No. 35. Rebuilt in the 1950s, this Exonian institution became Dingles in 1972, and is now known as House of Fraser. To this day it occupies Nos 30–35 in the High Street.

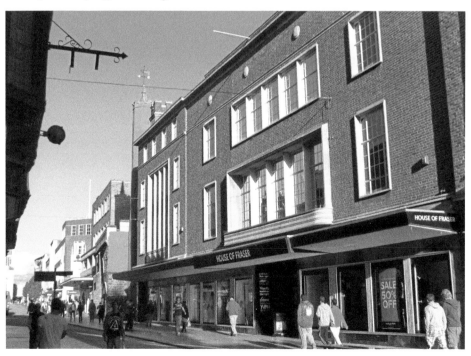

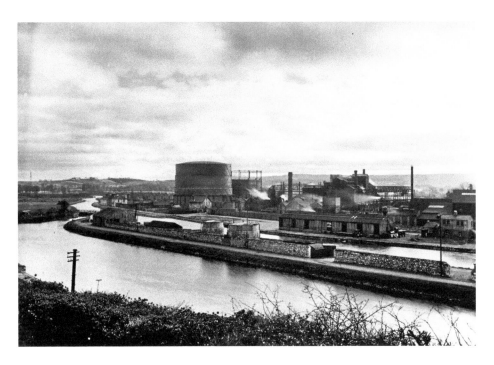

Gasworks, Haven Banks, Post-Second World War

Exeter's first gasworks was built between 1815 and 1817, on Exe Island, for the Exeter Gas Light & Coke Company. By 1874 the smell had become an issue for local residents, and as access to the site was difficult, production moved to premises at Haven Banks, which was rebuilt in 1878. In 1903 tramlines were constructed and the site continued to thrive, being extended in 1912 and again in the 1920s. Production ceased in 1971, however, and the plant was demolished in 1973. Today, only the gasholders remain.

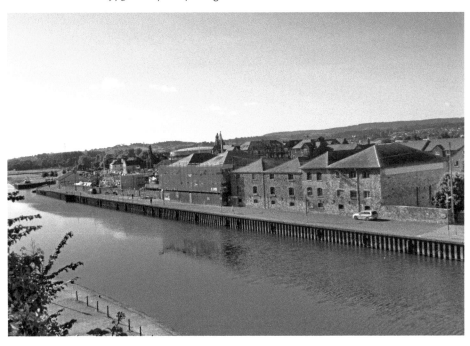

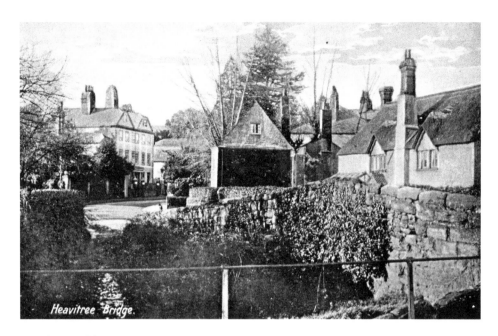

Heavitree Bridge, *c.* 1925

Locals still speak fondly of the old stone bridge at the end of Sweetbrier Lane. The Bridge Inn, the toll house of 1830–84, and the thatched buildings of Birchy Barton Farm must have added to the charming bucolic scene. Those condemned to death passed this way to the gallows where the road splits for Honiton and Sidmouth. Rifford Road was developed in 1933, the adjacent flats a little later. Today 'Brook Cottages' remain but otherwise all is cars, traffic lights and box junctions.

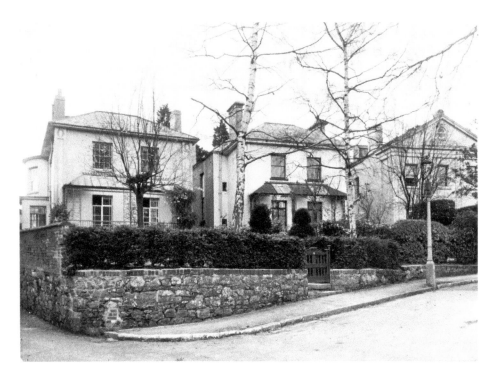

Pennsylvania Crescent, *c.* 1950

It is worth seeking out the fine Regency villas of Pennsylvania Crescent. Built around 1823, and given their present name in 1905, they overlook their own private garden. Having lived at No. 1 (Marypole Villa) I can attest to their charm and their generous internal proportions. Crescent House, in the centre, is in the Greek revival style, while No. 5, adjacent to Hoopern Lane, has an unusual two-storeyed bow window. The coach house and stables are now occupied, appropriately, by a car repair business.

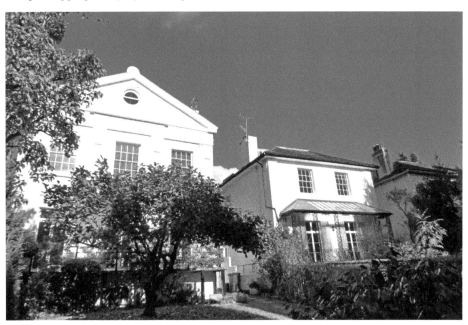

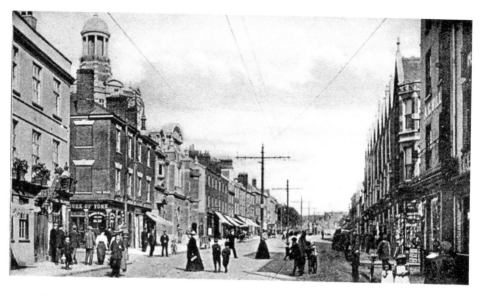

Sidwell Street, *c.* 1900

No-one drives animals to the slaughterhouse on the corner of Summerland Street anymore. Its approximate site is now a launderette. Eveleigh's petrol station – very useful in its day – has become a post office and flats, but this area continues to buzz. The Duke of York sits at the heart of things, the revolutionary concrete features of the Methodist church beguile the knowledgeable passer-by, and the long-established furniture emporium of Stoneman and Bowker is, as I write, being turned into student accommodation.

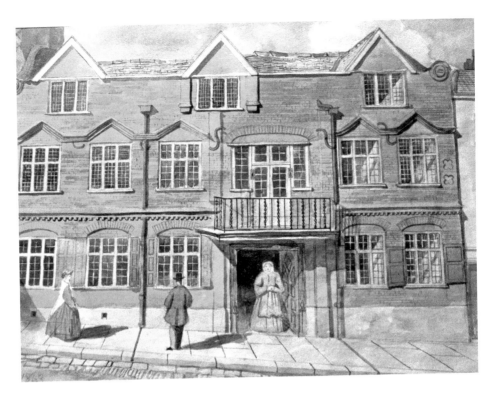

Old House, Paris Street, 1863

From 1871, and possibly earlier, this building was the Paris Street Boys' School, supported by Plymouth Brethren. In around 1888 it became the Paris Street Boys' and Girls' School, continuing as such until around 1914. From 1935 to 1947 it became Elim tabernacle and is listed from 1949 to 1957 as Elim church. This stone building, on the corner of Cheeke Street (located differently today), stood where vehicles now leave the bus station. It acted as a firebreak during the Blitz.

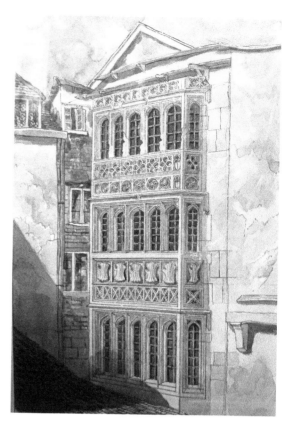

Elyot's House, 73 High Street

Thomas Elyot, Comptroller of the Royal Customs for Exeter and Dartmouth, lived at No. 73, High Street, adjacent to St Petrock's church. The house was built in 1450–1500, and in 1504 Elyot gave it to St Petrock's. In 1845 Bishop Phillpotts bought the fine three-storeyed bay window, prior to the house being demolished, and installed it in the Great Hall of the Bishop's Palace during a major restructuring. There it remains, partly glazed with stained glass saved from work to other parts of the palace.

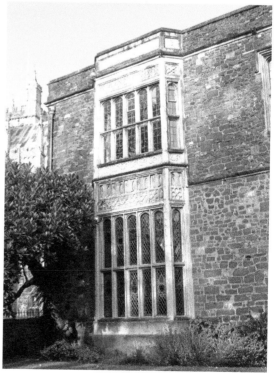

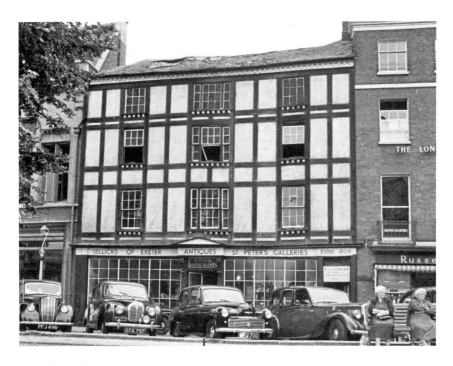

22 Cathedral Yard, *c.* 1955

From around 1929 until 1959, these premises were occupied by Sellicks (cabinet maker's, antique dealer's, estate agent's and remover's). A furniture outlet of Colsons, from 1959 to 1963, the building then became the regional head office of Fox & Sons, a large south coast estate agency group. Luget's, gentlemen's outfitters, moved here from Little Castle Street in 2000 and, after a refurbishment in 2009, continue to clothe Exeter's best dressed men, as they have since 1814.

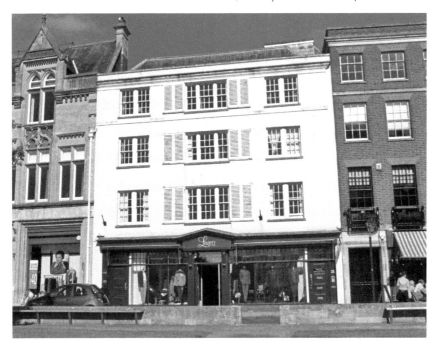

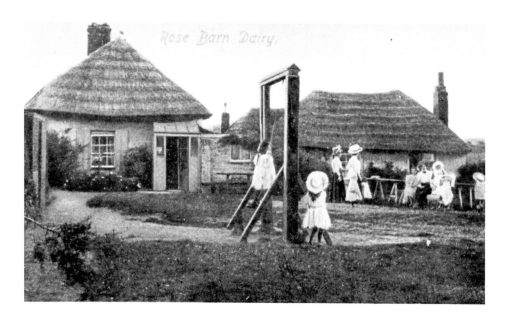

Rose Barn Dairy, Rosebarn Lane

According to Professor Hoskins, Exeter's best-known historian, a butcher named Rowe leased some fields hereabouts and erected a barn in about 1700, hence the name. The Rose Barn Dairy became popular in the early twentieth century as a spot for refreshments after toiling up the hill, and children would play happily on the swing in the garden of this thatched farmhouse. In 1968, with Exeter constantly expanding, Collins Road was developed, and today nothing remains of this once popular destination.

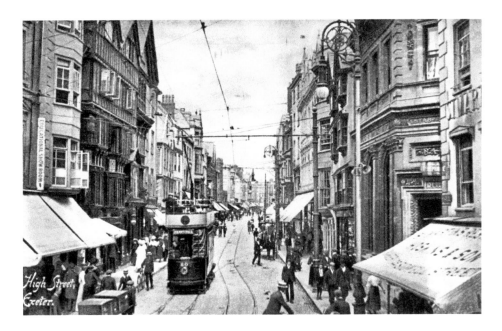

High Street, c. 1910

Part of an Iron Age ridgeway, and first laid out by the Romans, the High Street continues to evolve. This venerable thoroughfare was thronged with early cars, trams, bicycles and horse-drawn carts at the beginning of the twentieth century. After the Blitz, when St Lawrence's church was lost, pavements were widened as shops were rebuilt. Today, only McGaheys the tobacconist survives to represent the independent retailers. We now have Build-a-Bear, Jessops, Thorntons, mobile phone shops and coffee outlets instead.

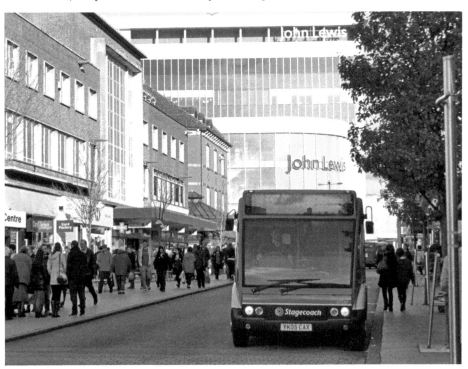

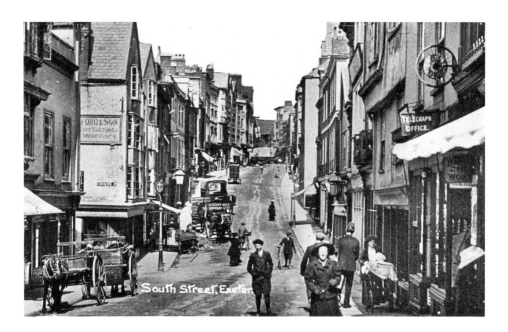

South Street, *c.* 1906

Somewhat narrower and more intimate at this time, South Street was full of independent retailers. Mrs Pugsley made Honiton Lace, Mr Chapman was a bookbinder, Mr Trenchard made umbrellas, there were two saddlers, and even a glass embosser. Badly damaged in the Blitz, the college of the Vicars' Choral is gone, as is Bear Tower – the remains of a fourteenth-century house at one corner of Bear Lane. This was demolished in 1966. Today, we have estate agent's shops, charity shops and a taxi firm, among others.

The White Hart Hotel, South Street

This ancient hostelry, which seems to defy dating, was possibly the private residence of William Wynard in the fifteenth century. He left it as an endowment for his eponymous almshouses in Magdalen Street, and it became the Blue Boar Inn before getting its present name. Located just inside the South Gate, it was well placed to act as a coaching inn. Now run by Marston's plc, the cobbles, the beams and the panelled ceilings continue to evoke memories of days gone by.

Old Tiverton Road, *c.* 1935

Until New North Road was constructed in 1834, Old Tiverton Road was the main route to North Devon. Occupants of the buildings shown in around 1935 included a greengrocer's, a bootmaker's, a hairdresser's, a confectioner's, and Miss Hill, teacher of pianoforte. At the junction with Blackboy Road we have St Ann's chapel of 1418, and associated almshouses which date to the middle of the sixteenth century. Today's businesses include a Chinese takeaway, a grocery store, a solicitor's office and an electrical goods shop.

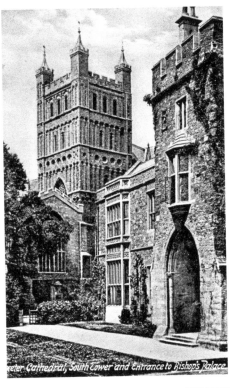

Exeter Cathedral, South Tower and Entrance to Bishop's Palace

The Bishop's Palace, Palace Gate

Hoskins suggests that the Bishop's Palace
now stands on what was once the site of
an abbey dedicated to St Mary and St Peter.
Ewan Christian remodelled the interior of this
thirteenth-century building in 1848, and in 1875
William Butterfield modernised the fourteenth-
century gatehouse. In 1845 a bay window, dating
from 1450–1500, was installed in the great hall;
it came from 'Elyot's House' in High Street. Parts
of the building are now used for administration,
and until recently the cathedral library was
housed here.

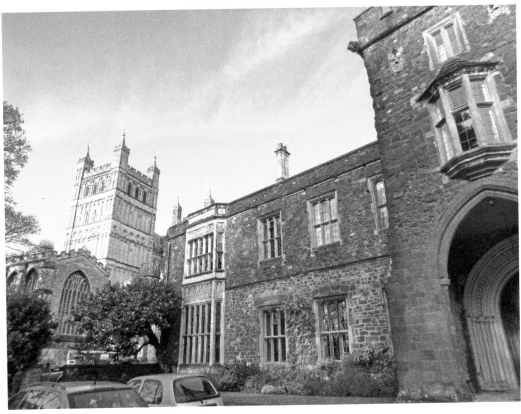

Southernhay West, *c.* 1935

In 1792 the 5th Duke of Bedford engaged Matthew Nosworthy to develop part of his landholding. This substantial scheme, which we know as Southernhay, required several builders, and wasn't completed until around 1825. The west side was originally four terraces, of which two survive; in 1974 Broadwalk House replaced the others, which had suffered bomb damage. In 1989 the purpose-built Southgate Hotel opened, then run by Trust House Forte, today operated by Mercure. Solicitors, accountants and estate agents occupy the beautiful town houses today.

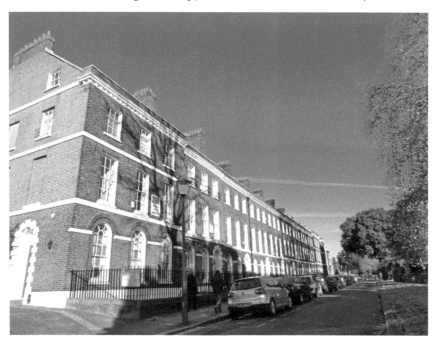

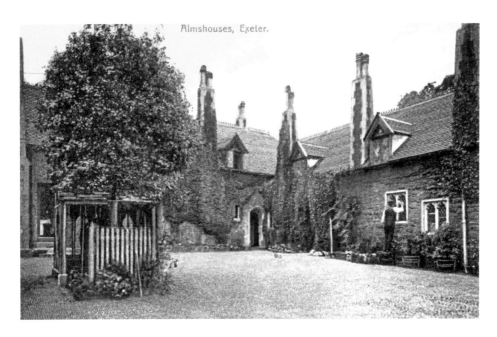

Wynards Almshouses, Magdalen Street, c. 1906

It was the owner of the White Hart in South Street, William Wynard, who developed this small 'hospital' for paupers in 1436. Built of Heavitree stone, the dwellings and the integral Trinity Chapel form a quadrangle around a cobbled and lawned space with a surviving well house. In 1863 the Kennaway family restored the buildings, which had been fortified – and substantially damaged – during the Civil War. Used from 1972 to 2001 by the Citizens' Advice Bureau, Wynards is now used as private dwellings.

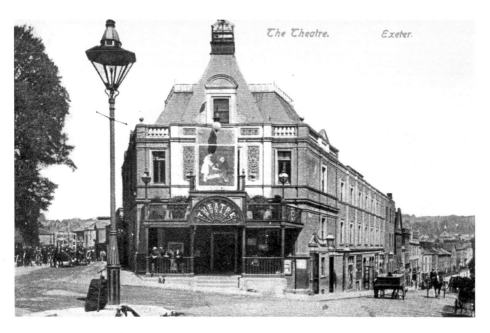

The Theatre. Exeter.

Theatre Royal, Longbrook Street, c. 1900

In March 1820, fire destroyed the theatre adjacent to Bedford Circus. Early gas lighting was blamed. The 'New Theatre' opened in January 1821. In 1885 this building was similarly gutted. The Theatre Royal opened in Longbrook Street in 1886. On 5 September 1887 a major fire claimed the lives of 187 people. The theatre reopened in 1889, before finally closing in 1962. The building was replaced with Portland House, the offices of Prudential Assurance, in the following year. Various companies now rent the offices.

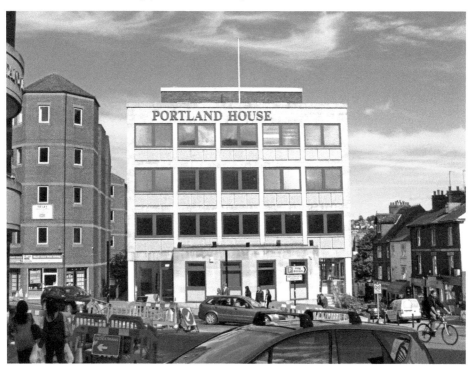

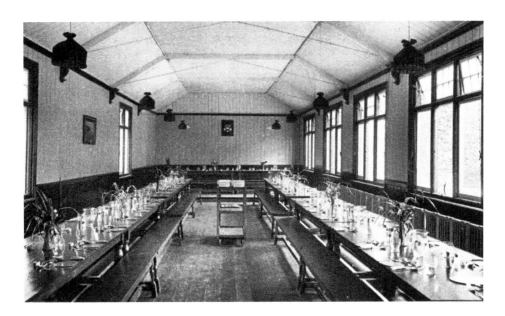

The University, 1920s

The School of Art opened on New Year's Day, 1855. In April 1863 the School of Science was born. In 1869 they both moved into part of the new museum. By 1900 a university college was established (London University controlling examinations) and in 1911, with extra accommodation urgently required, Bradninch Place was redeveloped. In 1922 the 120-acre Streatham estate was acquired, and on 21 December 1955 full university status was granted. The early photograph shows the dining room at Reed Hall. Today, this thriving institution enjoys a worldwide reputation for its teaching.

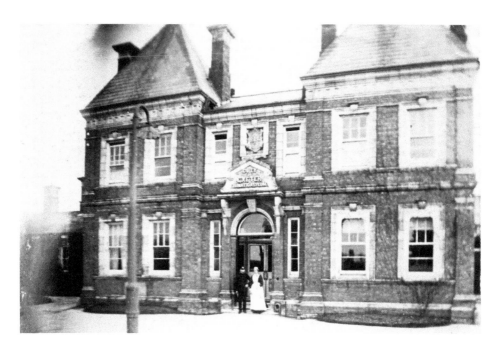

Digby Hospital, Woodwater Lane, *c.* 1900

Sited well away from the city, and with 'City of Exeter Lunatic Asylum' carved above the door, this institution opened in 1886. Thankfully, the locals swiftly renamed it 'Digby's Hospital'. Staff and patients were transferred to Exminster Hospital in 1942 when the US military commandeered the building; it returned to its former use in 1947. In the 1970s it became more of a day hospital, as inpatient numbers were reduced, and it closed in the late 1980s. The site is now Clyst Heath, a popular residential area.

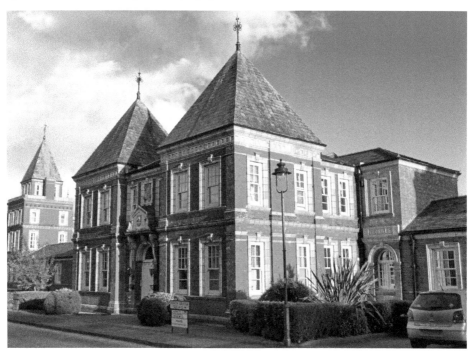

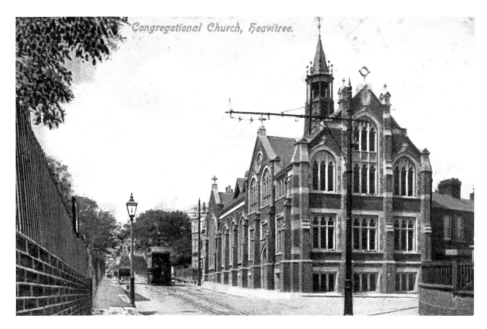

Heavitree Congregational Chapel, Fore Street, Heavitree, *c.* 1905

Frederick Commin was busy in 1902, designing both this building and the Methodist church in Sidwell Street. Local builder Stephens & Son charged £4,000 for their work, and gave us buttresses, gables terminating in finials, a small spire, and a great many windows. It's all rather Gothic and in considerable contrast to the neighbouring Regency villas. Today the Heavitree & Pinhoe United Reformed church, this genuine landmark is much loved and well used, particularly by the local Parent and Toddler Group.

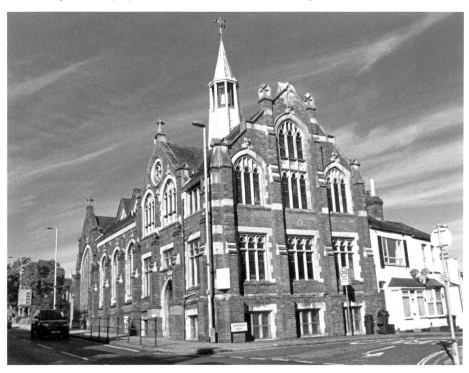

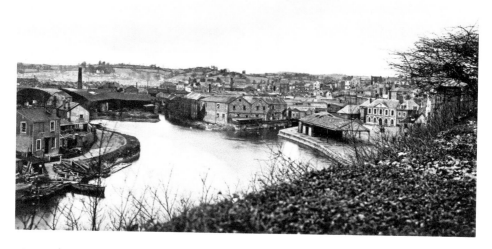

The Quay & Shilhay, Post-Second World War

Exeter's wealth was generated, largely, by the wool trade from the twelfth century to the early nineteenth. Brewing, tanning and flour production also required mills, and Shilhay became the city's first industrial estate, developing hand-in-hand with the Quay. The Napoleonic Wars disrupted trade, however, and manufacturing eventually declined. The land either side of the Exe was redeveloped as housing; today we have the Waterside apartments, Piazza Terracina – a mixture of homes, shops and cafés – and the award-winning estate known simply as Shilhay.

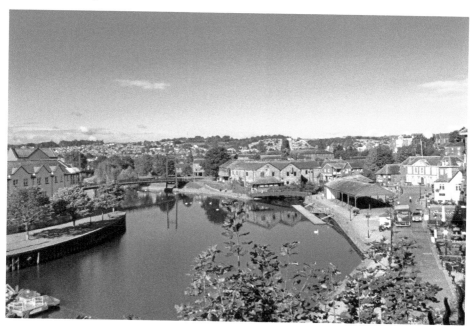

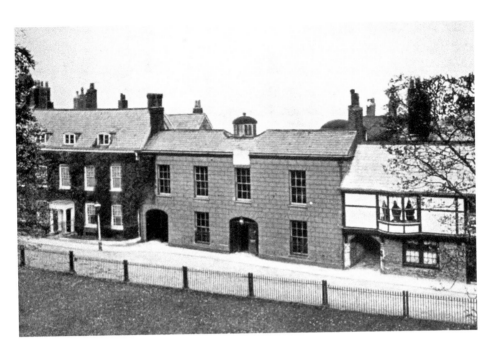

The Devon & Exeter Institution, 7 Cathedral Close, c. 1913

In a beautiful building overlooking the cathedral lives the Devon & Exeter Institution, a private library formed in 1813 for the '... general diffusion of Science, Literature and the Arts ...' The building, medieval in origin, was the town house of the Courtenays, Earls of Devon, and today accommodates a collection of books, maps, prints, newspapers, journals and reports of national significance. A cinema club and a full programme of lunchtime lectures, social evenings and summer outings are offered to the current membership as the institution proudly celebrates its bicentenary.

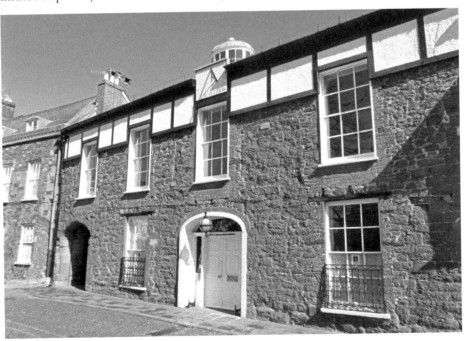

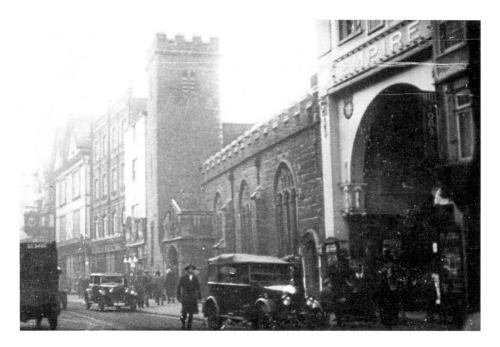

High Street, 1930s

St Lawrence's church, of around 1222, was destroyed during the Blitz, and was superseded first by Commercial Union and then by Lloyds TSB. The Empire Electric Palace opened at No. 248 in 1910 and offered a daily continuous screening, with live piano accompaniment, from 3 p.m. to 10.30 p.m. It closed in 1937 and the building suffered the same fate as the neighbouring church. Today we have Jones (a shoeshop), O2 and Virgin.

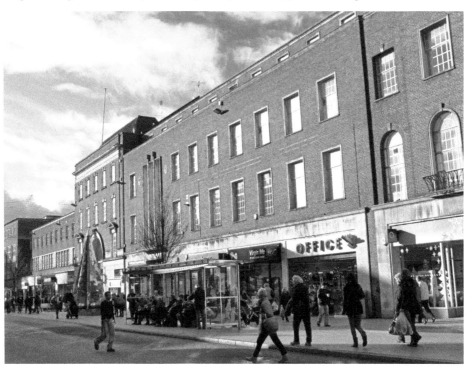

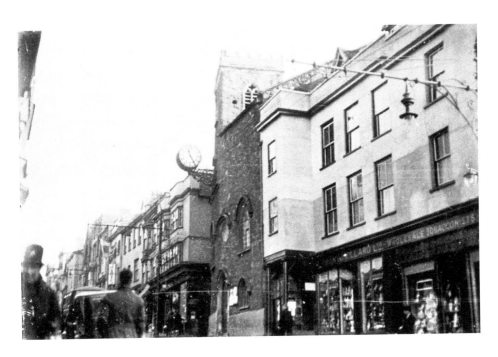

Fore Street, 1930s

Shops on this part of Fore Street in the 1930s included Jay's Furnishing Stores, Broughton the hosier and hatter, and Pitman and Millard, wholesale tobacconists. In between was the church of SS John and George, on the corner of John Street. Affixed to the church tower was the 'moon of Fore Street', an illuminated clock which in Victorian times had been fitted with an extra hand so that it could indicate both 'train time' and 'Exeter time'. This site is now occupied by Taunton Leisure, outdoor specialists.

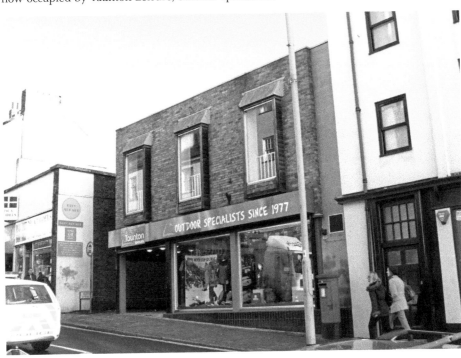

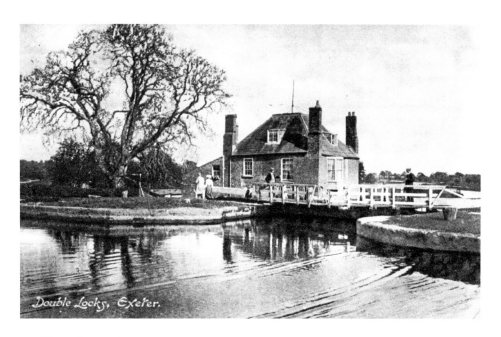

Double Locks Hotel, *c.* 1920

The continuing success of the wool trade necessitated the enlargement of the canal at the very end of the seventeenth century. This was done between 1698 and 1701; the scheme was completed with a lock-keeper's cottage. The cottage was used simultaneously as an inn from the end of the eighteenth century, and was remodelled in 1827 when the canal was extended again. Currently run by Young's, the pub is well known for its summer programme of live music.

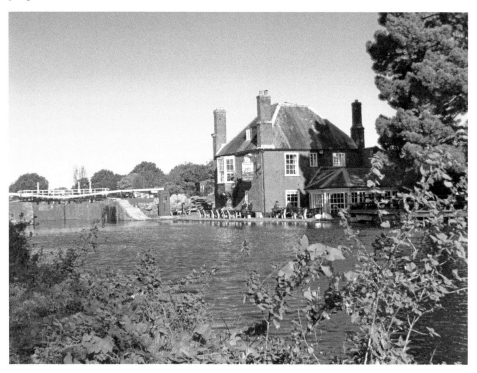

Queen's Terrace, Post-Second World War

Adjacent to the Clock Tower and Queen Street, this elegant 1840s street is somewhat quieter. Number 10 has been known for a long time as Bury Meadow House; the Christian Alliance of Women and Girls' Club was at No. 12. From at least 1877 up to the end of the Second World War, one end of the terrace was the Osborne Temperance Commercial & Family Hotel, latterly known just as the Osborne Hotel. After that it became the offices of the National Farmers' Union and then a succession of pubs.

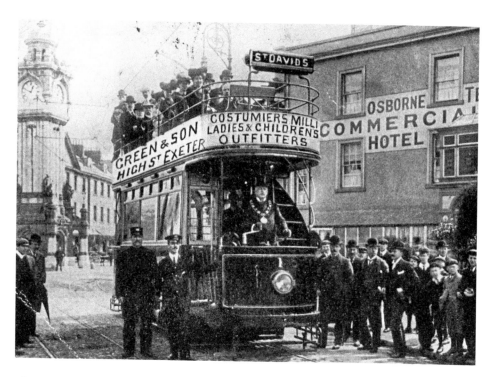

The Trams, 1905

Construction of Exeter's horse-drawn tramway started in January 1882, and services began just three months later. From London Inn Square one could travel to St David's station, Livery Dole and Mount Pleasant. Initial opposition from traders in the High Street and Queen Street was overcome by the success of the other routes; when electricity replaced horsepower in April 1905 the network was extended. Ultimately defeated by motor cars and delivery vans, which caused congestion yet possessed greater versatility, the service ended in August 1931.

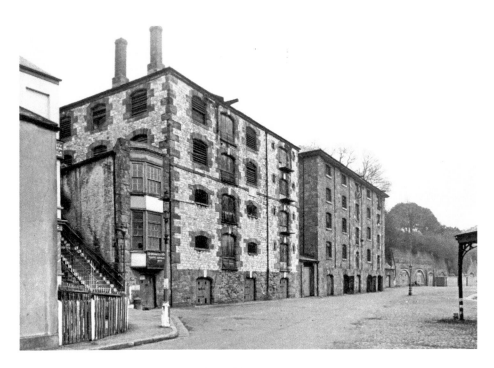

Warehouses, the Quay, Post-Second World War

Dominating the Quay are two substantial warehouses. One was built in 1834, of Pocombe limestone, by Cornish and the other was built in 1835, of Heavitree breccia, by Hooper & Hooper. Both five storeys high, the two buildings are now linked by a modern glass structure. Part of the Maritime Museum from 1972, they were converted into apartments, before becoming offices in 1988. Christie & Co. and LDA Design are among the tenants, while Saddles & Paddles, Mango's and Quay Presents occupy the ground floor.

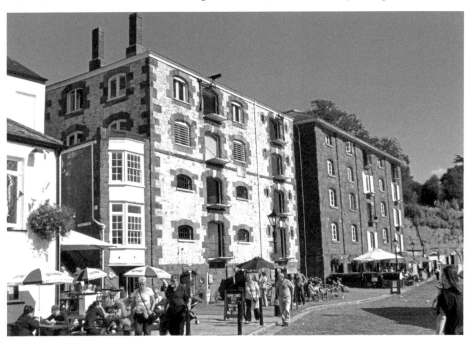

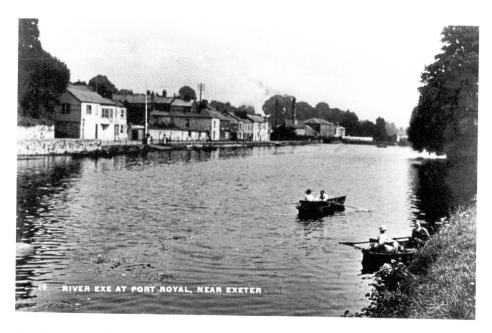

Port Royal, Weirfield Path, 1930s

A public house since the 1840s, Port Royal became the home of the Exeter Amateur Rowing Club in 1864. The club left in 1981 and its facilities were subsumed by the pub. In 1905, electricity cables were run from the Tram Generating Centre in Haven Banks to St Leonards, going under the river and resurfacing at Port Royal. Early radio and television wires did likewise. The pub continues to thrive, as does the rowing club, and the Generating Centre is now an indoor climbing wall.

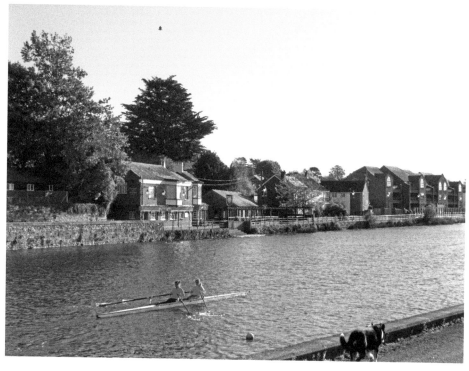

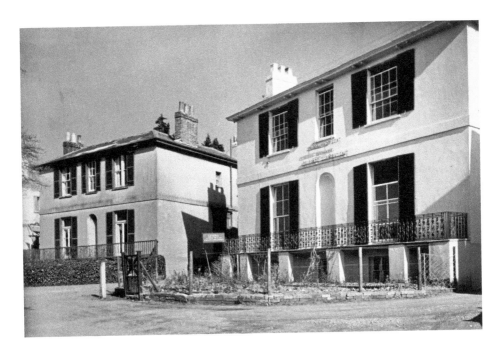

Baring Crescent

When built, between 1818 and 1828, these fine Regency villas were described as 'superior cottages'. The specification included eight bedrooms, a drawing room and a breakfast room, with full service facilities in the basement – superior indeed. Twelve were built and ten survive. The Baring family's wealth came first from wool and then from banking; the houses were built on the Baring estate, hence the name. Today we see a mixture of family homes and businesses.

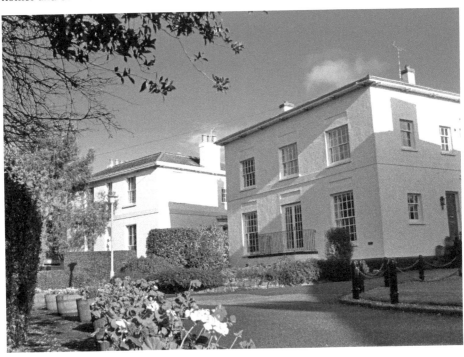

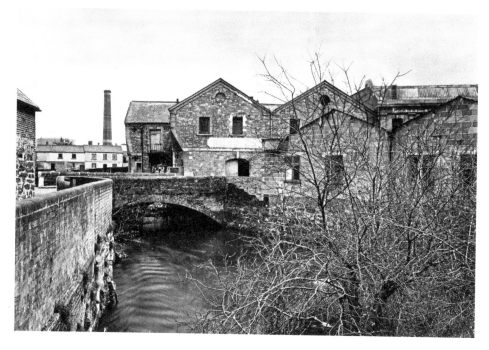

Bonded Warehouses, Commercial Road, Post-Second World War

Just yards from the Custom House, and on the site of the old Coal Quay, you will find these bonded warehouses. One was built in 1878 for Samuel Jones, a wine merchant, and the other was built in 1892 for the Kennaway family. The Kennaways were an important part of Exeter's mercantile elite; they successfully switched from wool to wine when the wool market declined. Their warehouse is now occupied by Quay Toning and Fitness. The other building, now empty, was a nightclub until 2009.

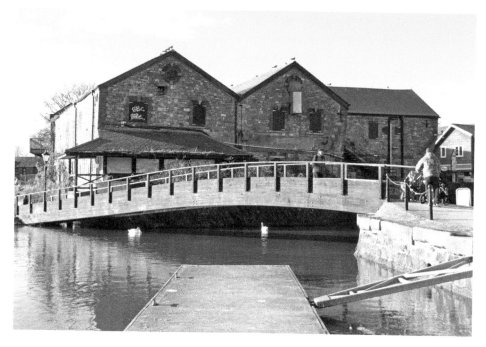

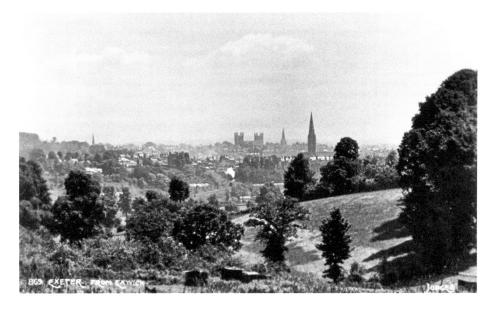

View from Exwick

The cathedral is the focus of this charming landscape, with the church of St Mary Major, demolished in 1971, alongside it. St Michael's church in Dinham Road completes the group; its spire is possibly the tallest west of Salisbury Cathedral. During the 1980s, Farm Hill in Exwick was developed and this altered the landscape considerably. St David's railway station and the new Premier Inn can be seen centrally, and one also notices the Exeter College building seemingly dwarfing the cathedral.

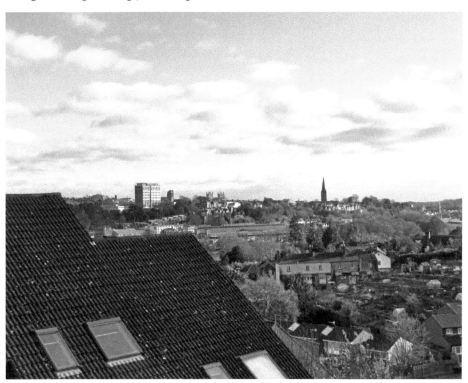

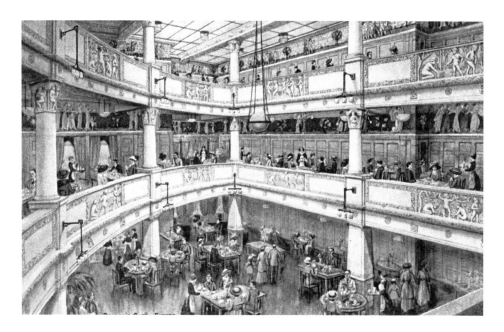

Deller's Café, High Street & Bedford Street, 1920s

A legendary part of Exeter's hospitality trade, Deller's opened on the corner of Martin's Lane in 1906. It proved enormously successful and moved to substantial new premises above and around Lloyds Bank on the corner of High Street and Bedford Street in 1916. The new building offered customers a theatre-like galleried restaurant, a ballroom, a public lounge, and various function rooms that catered for all manner of events, and all richly decorated. Damaged by fire during the Blitz, the building could have been saved, but was replaced during the 1950s. Today, Russell & Bromley occupies this prominent site.

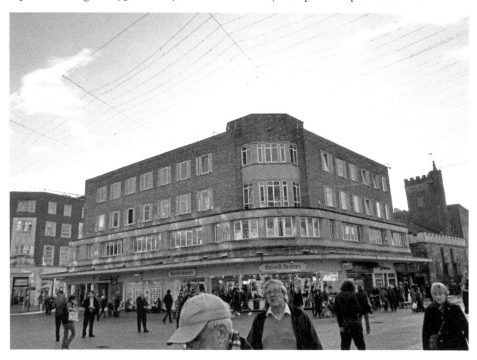

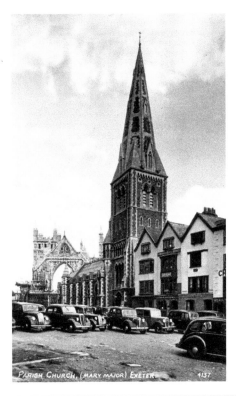

Little Stile, Cathedral Yard, 1940s

A footpath used to skirt the Globe Hotel and connect Cathedral Yard to South Street. This was Little Stile, and today all that remains are Nos 3 to 5. Little Stile Gate was demolished in 1820. This short terrace of timber-framed houses is sometimes known as Three Gables. Number 4 is dated 1540, but might be a little later. Cathedral craftsmen may once have lived here; the current occupiers are The Thai Orchid Restaurant, Space Hairdressing, and Al-Farid Moroccan Restaurant.

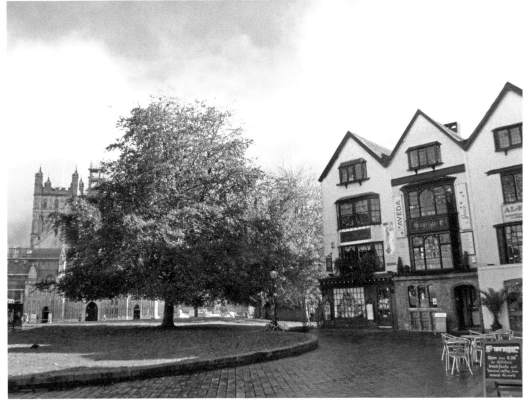

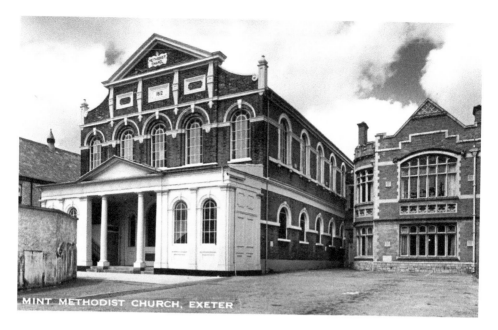

Mint Methodist Church, Fore Street, 1950s

Methodist numbers grew rapidly in Exeter at the beginning of the nineteenth century, and in 1812 the unitarian chapel in the Mint was purchased and demolished, to be replaced by the Mint Methodist chapel, with a capacity of around 700. Subsequent enlargements took the capacity to 1,000. In 1846 the Mint Lane Day School for Boys was opened; girls were admitted from 1854. Interment ceased here in 1867, although several headstones are to be found in the car park today.

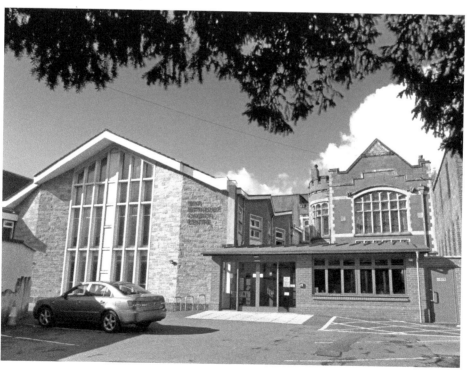

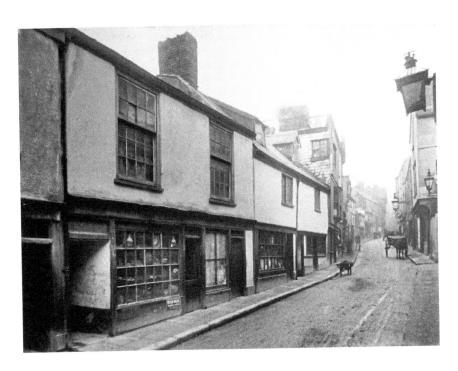

Paul Street, 1914

The city council already had plans in 1914 to widen Paul Street, at that time little more than a muddy lane. Behind these shopfronts were tenements known as Cornish's Court. Until replacements were built in Magdalen Street in 1879, St Petrock's owned almshouses here. Number 7, the property on the left, was owned by Richard Mears, a leather seller; the fabulous if smoke-blackened plaster ceiling was in the upstairs front room of his house. None of this survives.

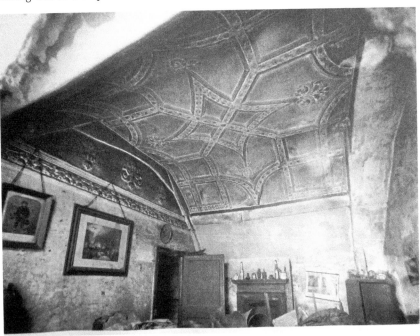

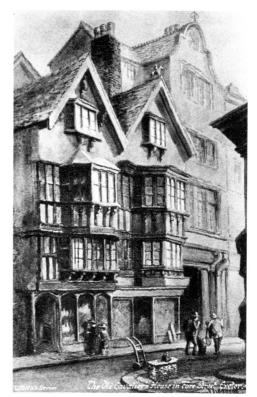

The Chevalier House, Fore Street

At the top of Fore Street there used to be a very fine pair of timber-framed merchants' houses, Nos 78 and 79. Number 79 was known as the Chevalier (or Cavalier) House, and dated to around 1640. In 1929, the neighbouring Woolworths shop wanted to expand, and the two houses were sold to the city to save them from demolition. In 1939 they became the Old Chevalier Inn, but this hostelry was destroyed in the Blitz. Wetherspoon's have run the pub, now known as The Chevalier Inn, since 2009.

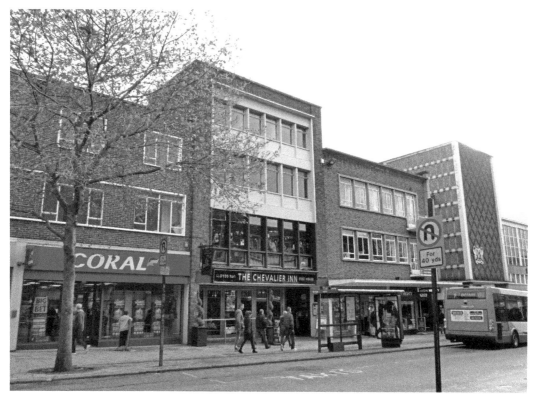

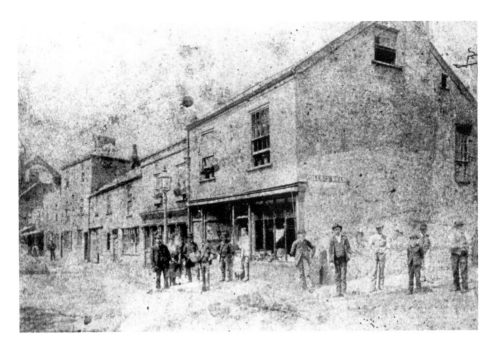

The Mount Radford, Magdalen Road, *c.* 1880s

This popular hostelry, on the corner of Magdalen Road and College Road, takes its name from Mount Radford House, demolished for Barnardo Road in 1902. College Road was constructed after the founding of the Exeter Diocesan Training College in 1854, now St Luke's Campus and part of the university. At the time of the photograph traders included the publican, a greengrocer, a tinman and a fly proprietor. Today we have the pub, Lloyds Chemists, Leela (a giftshop), the Bran Tub (a wholefood shop) and Weekes' estate agency.

Acknowledgements

I must start with thanking Dr Sadru Bhanji, who has given me unlimited access to his fabulous collection of old images, and has been extremely generous with his time and advice. Quite simply, this book would not exist without him.

Su Conniff and Roger Brien at the Devon & Exeter Institution have been unfailingly supportive of this project, and have made significant contributions. The officers of the Devon & Exeter Institution have kindly allowed me to photograph a variety of material, some previously unpublished. My thanks to them, and to all my friends at this extraordinary place, for their gentle encouragement; Jenny Dawson, John Manley-Tucker, Brian Le Messurier, Dr Pat Milton, Albert Felton, Malcolm Joyce, Jim Pilkington, Margaret Knight, Peter Wadham, Mark, Sara and Kelsey Ware, Stephanie Beddoes and of course little Eva.

Thank you to Conrad Donaldson, Sarah Johnson and Sue Cranch at the cathedral and the Bishop's Palace. Thank you for lots of things to Joey Lee and Simon Mills at the Hub On The Green. Thank you to Alan Darbyshire (Mace Sergeant at the Guildhall) and to Mr and Mrs David Baker, Mr and Mrs Ken Perryman, Norma Raddan, Alan Cotterill, and Deborah.

Thank you to Bernard Lane, Hilary Astwood and the late, wonderful Chips Barber, teachers of mine, who taught me to care, to think, and to respect history.

And to my parents for driving me around to take the photographs, my sister for typing my manuscript, and my partner for helping with marketing and publicity, endless gratitude...

Exe to Otter Through Time

Christopher Long & Kay Long

This fascinating selection of photographs traces some of the many
ways in which this area of East Devon has changed and developed
over the last century.

978 1 4456 0719 1
96 pages, full colour

Available from all good bookshops or order direct
from our website www.amberleybooks.com